SURREALISM

RENÉ PASSERON

Introduction 8

The Ascension 10

Psychosis and Poetry $14\,$

The Dada Storm 26

"Drop Everything!" 42

Plenitude 60

Surrealism Takes Hold 64

Love, the Tragic and the Sexual 72

Painting, Photography and Cinema $\,76\,$

Expansion 108

Back to Mental Pathology $112\,$

The Conquest of Objects 124

Political Problems 138

Around the World $\,154\,$

SURREALISM RENÉ PASSERON

K

SOUTH CHESHIRE COLLEGE CENTRAL LRC

Acc no A0050325
Date 12 05 Price 5 Supplier RL
Invoice No. 80.378
Order No. 48829
Class no 759 04063

Editor: Anne Zweibaum and Christine Marchandise Graphic designers: Sandrine Roux/Caroline Keppy Layout: Anne Sol Translation: Joan Koenig and Jack Liesveld

Iconography: Maryse Hubert
Copy editor: Christophe Gallier
Lythography: Grafiche Zanini

Publication number: 283 ISBN: 2-87939-299-3 Printed in Italy

© Éditions TERRAIL/ÉDIGROUP, membre de la SN des éditions Vilo, Paris, 2005, 25, rue Ginoux, 75015 Paris.

All rights reserved. No part of this publication may be reproduced or transmitted in any form or any means, electronic or mechanical, including photocopying, recording or by any information storage any retrieval system, without prior permission in writing from the publishers.

Cover illustration:

Giorgio De Chirico

The Vaticinator,

1914, oil on canvas,

Museum of Modern Art, New York.

Dispersion 168

Exile 174

"We Are Here to Stay." $190\,$

The Return of Breton 206

Artaud's presence 210

"Surréalisme Révolutionnaire" 216

Persistence 220

Friction and Polemics 224

Influence and Creation 230

Eros and Thanatos 240

"The final split" 248

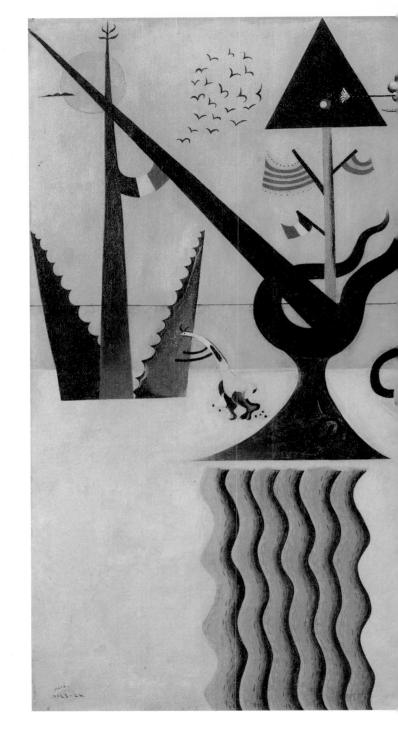

Joan Miró Plowed Land, 1923, oil on canvas, Solomon R. Guggenheim Museum, New York.

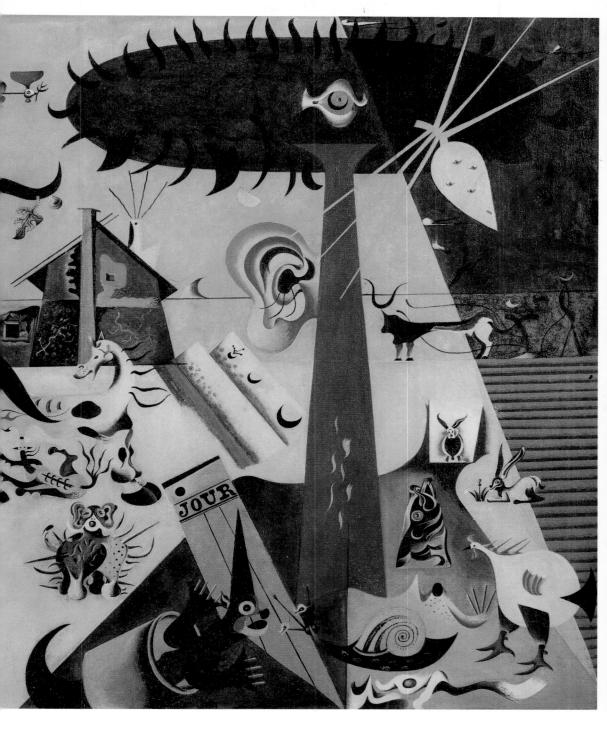

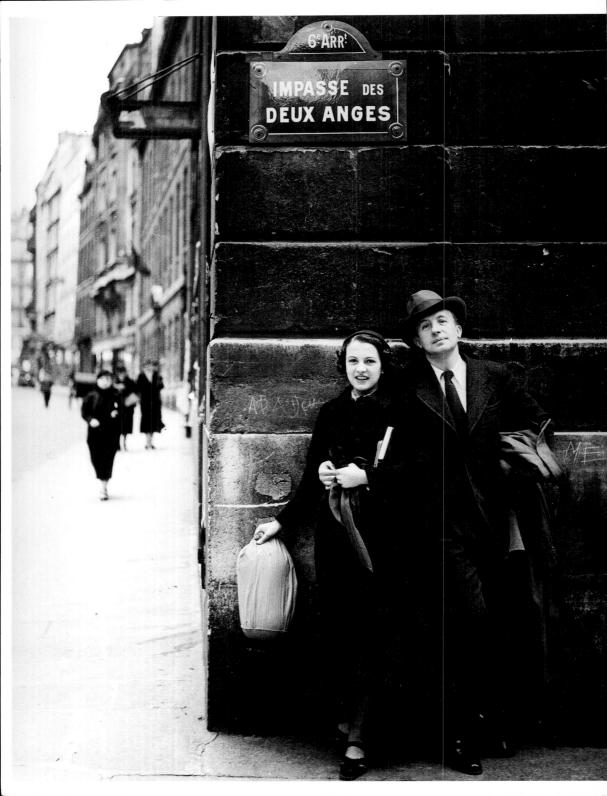

INTRO-DUCTION

The name "historical Surrealism" is sometimes given to a phenomenon of civilization that, between 1920 and 1940, drastically changed artistic creation in France, and later, throughout the world. The upheaval concerned mainly poetry and painting, but also personnel and private values. It is therefore possible to write its history. But the story would be superficial and anecdotal if the events were not accompanied by an evocation of the hidden side even more secret than what Walter Benjamin called "the last snapshot of European conscience".

Carrying the spirit of Romanticism and Symbolism into the 20th century, Surrealism was born in the aftermath of the profound shock of the First World War. Their experimental spirit and need for political commitment led the movement's poets toward an ethic of revolt, the consolidation of Freud and Marx. Then, after the Second World War, this desire to "change life" became progressively more pessimistic and libertarian, and was finally reduced to "l'amour fou" (wild love), tied up with the freedom of Eros.

This is all to say that Surrealism, with its stylistic diversity is not an artistic "school" like Cubism. Its greatest originality was the integration of artistic creativity with philosophy. It only provided some of the major works of the 20th century by making art a means of protest against morals and a means of knowledge of mankind. The persistence of this aim, more or less avowed, is still stirring today.

Man Ray

Nusch and Paul Éluard (impasse des deux-anges), About 1934, gelatin silver print, centre Pompidou-MNAM-CCI, Paris.

THE ASCENSION

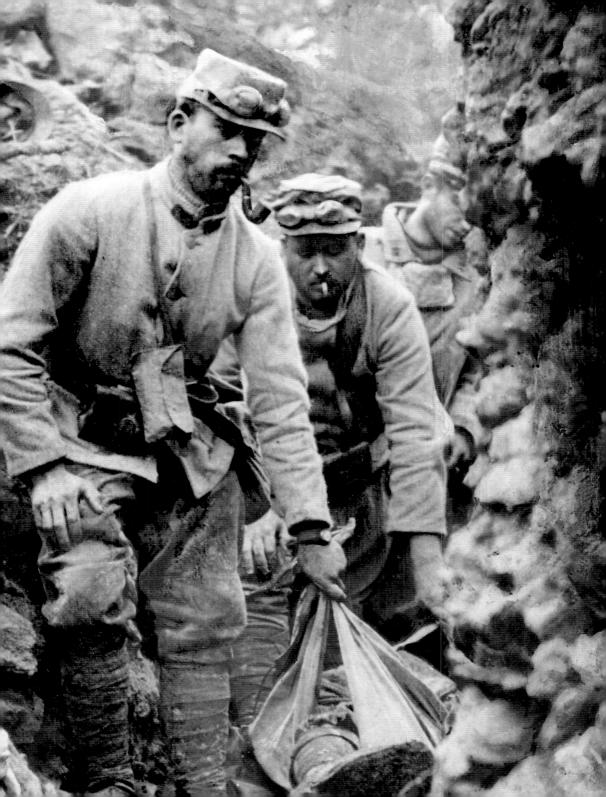

The First World War ravaged the continent. 1916. In the Bay of the Somme in northern France, the English army wallowed in the mud. In Verdun, the incessant firing on both sides pulverized anonymous bodies in the name of some horrible notion of glory. "Raise the dead!" Le Chemin des Dames leads only to death. In April 1917, the miserable failure of the almost month-long Nivelle offensive aroused public indignation. Revolt began among the soldiers reclaiming equal rights in the face of death. In the Chambre des députés, the Socialist deputy Brizon openly denounced the massacre. Fifteen thousand women went on strike. Mutiny was to be severely punished. The previously censured "chanson de Craonne" was adopted as a revolutionary anthem. Health services were unable to cope with more than one hundred thousand wounded, without counting those who'd gone crazy. The only glimmer of civilization in the midst of this symphony of pain and hatred came from care. Stretcher-bearers, doctors, nurses, volunteers in the Red Cross and in the overcrowded hospitals - there, a tremulous remnant of the human spirit remained. Is it a coincidence that the future Surrealists, having understood throughout the war the degree of protest necessary, indeed even anarchist revolt... Is it a coincidence that André Breton and Louis Aragon, both young interns mobilized to care for the wounded, and Breton, fascinated by the fate of the mentally ill – were all to be swept up in a sort of generalized neurosis?

In July 1916, Breton, a medical auxiliary in Nantes, was transferred at his own request to a psychiatric hospital in Saint-Dizier. The hospital regrouped soldiers driven mad by the war, as well as prisoners awaiting trial. This is where the notion of Surrealism was born. Breton states in Entretiens (Interviews, Gallimard, 1952, p.29]: "The time spent in this place, and the attention with which I studied what was happening have counted immensely in my life and have undoubtedly had a decisive influence on my manner of thinking." His letters dating from August of 1916 to Paul Valéry, Guillaume Apollinaire and Theodore Fraenkel (also a medical student in Nantes) showed to what extent Breton, already a poet, was intrigued by the stranger functions of the mind. The reading materials that his senior advisor, Dr. Leroy provided him with, led to his request for transfer to the care unit of Babinski, the noted neuropsychiatrist at the Salpêtrière, hospital in Paris.

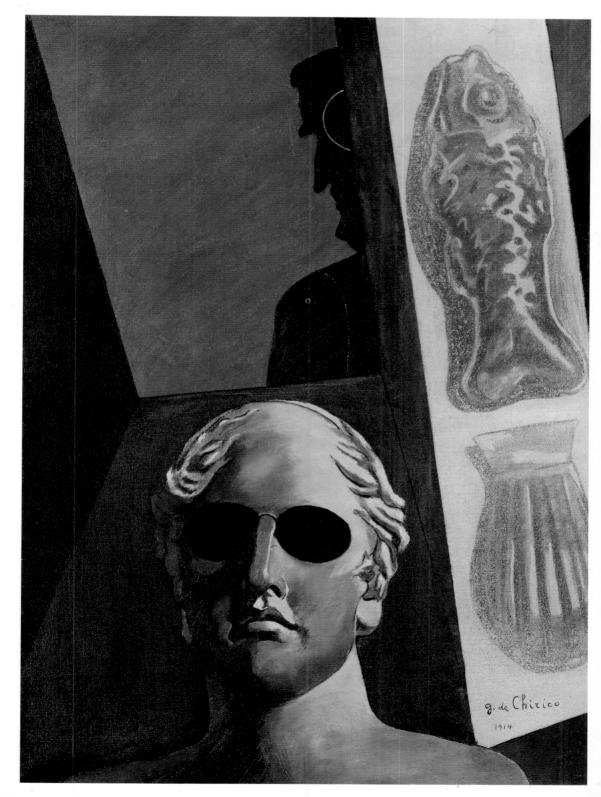

Previous page:
Giorgio De Chirico
Premonitory Portrait of Guillaume Apollinaire,
1914, oil on canvas,
centre Pompidou-MNAM-CCI, Paris.

He arrived in 1917. Breton would keep Babinski's works in his library throughout his life. Babinski maintained that hysteria is a purely mental phenomenon, with no neurological basis. This is a notion that would be taken up by Surrealism, when Breton was to compare it to the poetic power of delirium in his *Éloge de l'hystérie* [In Praise of Hysteria, 1928] or in *The Immaculate Conception* an essay of pathological simulations. It is with a poet's eyes that Breton first read Freud and Kraepelin (the author of several definitive books on paranoia) — "Precocious dementia, paranoia, twilight states, Ah, German poetry, Oh Freud and Kraepelin!" Breton wrote in a letter to Fraenkel, September 1916.

Poetry, German or not, was close to Breton's heart. And if he then tried to go against his heart, his taste for scientific knowledge couldn't hold him back, for all that,

from pursuing medicine. He would attempt, rather, to make poetry itself a means of knowledge. There, we find the legacy of a certain European Romanticism and Symbolism – the essential path for the Surrealistic adventure in the future.

In November 1916 Breton was assigned to a unit of stretcher bearers (along with Fraenkel) and plunged into the "vertigo" of the atrocities of the front. A poem describes this state: *Soldat* sent to Apollinaire 20 December 1916 — poetry offering an apology for delirium as a means of escape from the unbearable reality, a way of spiritually surpassing the "vie sordide" (sordid life). The experience of the mentally ill brings an absolutely new dimension to modern poetry, as seen already in 1916 in the Surrealist movement in the making. The "déréalisation surréa-

liste" (Surrealist Derealization, *Philosophie du surréalisme*, Alquié, 1955) which Breton was to clearly affirm in his "discours sur le peu de réalité" (Discourse on the Lack of Reality, 1924), would make poetry the "compensation for the misery we have to bear".

Breton's stay in Paris in 1917 provided many important encounters. He frequented Apollinaire, who introduced him to the poet Philippe Soupault, a fellow admirer of Rimbaud. In late September at a party in a barrackroom in the Val-de-Grâce (military) Hospital, Breton met Aragon. What followed was the kind of endless conversation filled with wonder, the kind that can only take place between two twenty-year-old poets. "sur ce boulevard sans cesse remonté, redescendu" (On this street, endlessly walked up, walked down)...

à monsieur Jasques Doucet

max ernst

Max Ernst

Double Portrait of Paul Éluard and Max Ernst, 1925, drawing on paper, bibliothèque littéraire Jacques Doucet, Paris.

Louis Aragon was the illegitimate child of a police official, Louis Andrieux, and a woman so young that for some time, she would pass herself off as being Aragon's sister. His father never acknowledged him, and from early childhood he displayed an extreme sensitivity. From this first meeting with Breton, a friendship was born. Breton's prolific readings of Aragon were to open up new perspectives of poetry which followed that of Rimbaud, Stéphane Mallarmé, Pierre Reverdy, and were often marked by the memory of Jacques Vaché, whom he'd met in Nantes. It was Vaché, with his peculiar form of nihilitic dandyism in his dazzling Lettres de Guerre (War Letters, published in 1919), that would revive a latent pessimism in Breton - his childhood had not been a happy one, anunloving mother, sometimes prone to violence were a somber backdrop to Breton's solitary nature - which, as a poet and a theoretician, he never managed to fully hide.

During the years between 1917 and 1920, destiny seemed to lead the future Surrealists'paths one towards the other. Eugene Grindel was treated for tuberculosis in a sanatorium in Davos. During those years, free from his family, Grindel read Whitman, de Nerval, Baudelaire, Rimbaud, Apollinaire's Les Soirées de Paris, Marx and Lautréamont. Released on the eve of the war, sent directly to the front, he would remain there for the entire war. Gassed, suffering from pulmonary gangrene, he was discharged in 1916. That same year, he adopted the pen name Éluard, his grandmother's name, and published his first collection of poems, Le Devoir (Duty). In Davos, he met Helena Dmitriovnia Diakonova, whom he called Gala. He married her in 1917 Gala would be his muse until 1930 when she married Dali. She was to remain a mastermind behind the Surrealist movement for many years. Le Devoir et l'Inquietude (Duty and Anxiety) was published in 1917 and Éluard joined the group of the review Littérature in 1920. He was to become one of the most important poets of the 20th century.

The artilleryman Max Ernst could have showered with shells the infantryman Paul Éluard in the Somme during the war years, but destiny would have it otherwise. They met in Paris later, becoming close friends. As for Benjamin Péret, he enlisted at the age of 16. Fleeing his family, he fought the entire war, first in a Calvary regiment, then in a unit specializing in sound detection. Due to the French occupation of the Rhineland, he was discharged only in 1920.

The painter André Masson was one of the most affected by the war. Mobilized in 1915, he was seriously wounded in April 1917 in the Chemin des Dames battle. Dragged from hospital to hospital, including the Maison-Blanche Psychiatric Hospital, he would only be discharged in 1918. He wrote in his memoirs, *La Mémoire du monde* (World Memoirs, 1974), that his sense of self "had been forever damaged..."

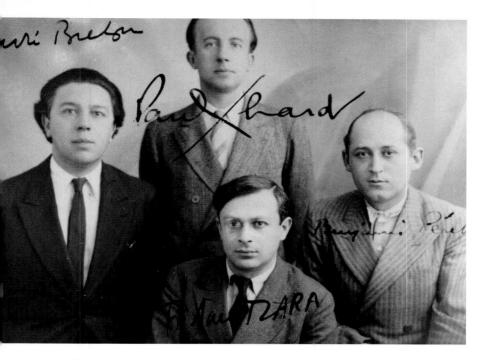

dré Breton, Paul Éluard, Tristan Tzara and Benjamin Péret, 32,

liothèque littéraire Jacques Doucet, Paris.

Cover of Littérature n°1, 1919, bibliothèque littéraire Jacques Doucet, Paris.

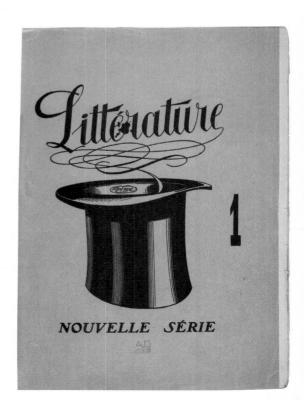

Littérature n°5, Ist October 1922, bibliothèque littéraire Jacques Doucet, Paris.

In his painting we find recurring themes such as the wounded bird, tearing apart, viscosity – all disturbing gore. But we'll come back to this.

While the aforementioned were on the battlefield, the young poets in Apollinaire's circle were discussing psycho-pathological research. Seeking a new form of poetry, beyond Reverdy's Symbolism and Mallarmé's verbal asceticism, they tossed about ideas that would take form some time later. Breton's liveliest repartees took place with Reverdy. For Reverdy, poetry, as all works of art carry with them a new form of reality with no direct relationship with life. Thus, art should be a presentation of art itself, and not a representation of a reality lived elsewhere. Breton compared this idea to the concept of poetry rather emanating from the darker side of life, where Eros would sustain the unpredictability of a poem. Already, the phrases de demi-sommeil - all that the spontaneity of the dream state suggests in everyday life, in desire, in love, indicate the emergence of a new path that would lead towards "automatisme" (the automatic writing) of the Manifeste (Manifesto) of 1924. Breton's lessons of desire are pertinent to the case. Poetry will be the

reality of the soul, not of things. A reality of language and its movements, of plastic shapes radiated by inner fantasies. Only allowing oneself to give into that which springs from a pre-conscious state will allow poetic energy to exist... In her monumental study, André Breton, naissance de l'aventure surréaliste (André Breton, Birth of the Surrealist Adventure, José Corti, 1975, p. 136), Marguerite Bonnet notes that Breton's poems from 1918 refrain from charming, but rather seek to displease by breaking language forms, to stifle the song while it's still in the throat (mettre le pied sur la gorge de sa propre chanson) according to Aragon's expression. This refusal of rhythm, or musicality in poetry - from Giorgio De Chirico to Éluard, by way of Marcel Duchamp - would be a constant in Surrealist expression. It would grow into a global refusal of any form of feeling, in any domain, even love, in favor of an interior clairvoyance and of a moral protest – a feeling that the Symbolist Odilon Redon found "bas de plafond" (without much up there - a loose screw), and that Duchamp condemned in impressionist painting as too "retina oriented" that same feeling that the Cubists had already

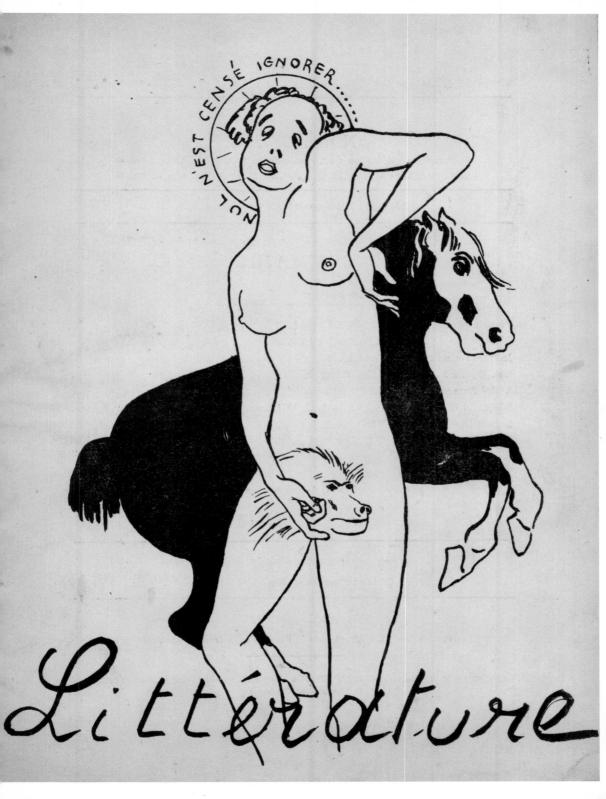

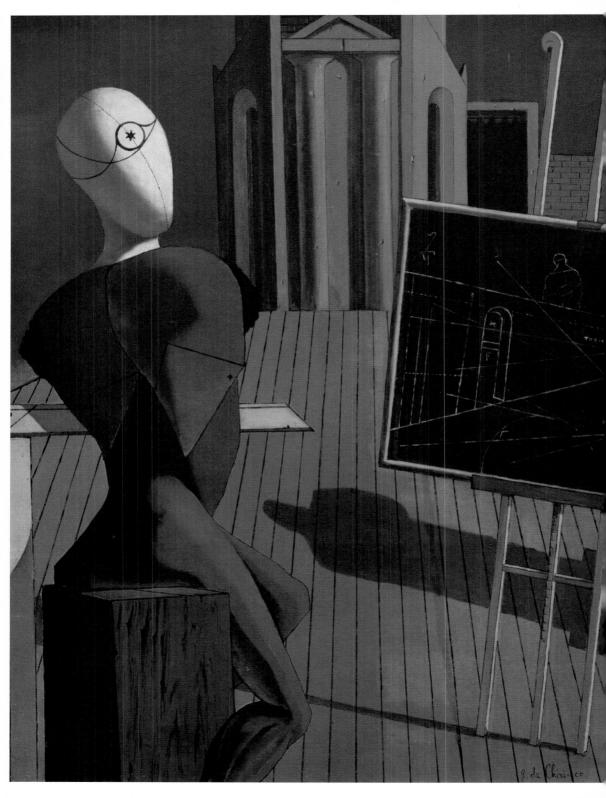

Giorgio De Chirico

The Vaticinator,
1914, oil on canvas,
Museum of Modern Art, New York.

surpassed, according to Apollinaire, by creating a new form of painting based not upon appearance but on structure.

Breton and his friends still hesitated, not knowing which way to turn. The end of the war was a time of strange developments, and people seemed almost surprised by the return of peace. Shouldn't we start all over again? Many artists and poets settled down. André Derain became classical and Vlaminck, the most violent of the Fauves, turned to painting the commonplace. Picasso went beyond Cubism toward his "période duchesse" the sketches of his young wife were worthy of Ingres. Apollinaire let himself be carried away by admiration for the Futurists, to extolling the war. He would die of Spanish flu at the time of the armistice (People in the streets were shouting, "Down with William" referring to William II, German Emperor, while he lay dying). Rumor had it around 1916 that there was a certain Cabaret Voltaire in Zurich, where something was being set up around Tristan Tzara. Feelers went out. The echo of Dada's effervescence had reached Paris.

In 1918 Breton and the future Surrealists were reading Lautréamont. They found in Les Chants de Maldoror a formidable expression of lyrical nihilism, excluding any resignation to void. "I made a deal with prostitution, in order to destabilize family life." (Chant I). Lautréamont's Dionysian immoderation and the force of his oratory style appealed to Breton's lyrical temperament. He soon left behind the punchy concision of Rimbaud, like that of Dada, favoring long phrases in the style of Chateaubriand. It is also noteworthy that Tzara too was a poet of inspiration - the Gongorism or declamatory style of Dada poetry and pamphlets, as Duchamp's play on words, would remain foreign to him. Often the same was to be the case for Surrealist poetry. Starting with Les Champs magnétiques (Magnetic Fields), an example of "automatic writing" published in 1919 by Breton and Soupault, Surrealism had achieved its first major work of poetry. The practice of "psychic-automatism" owes as much to Lautréamont as it does to the flow of words of certain mentally ill, previously mentioned. There is the new way. Is this a sign? The book ends with a dedication to Jacques Vaché...

The Ray

The Dada movement was founded in Zurich, 6 February 1916, by Hugo Ball, and given this ridiculous name completely by chance. Meetings were held at the Cabaret Voltaire, in an atmosphere charged with unrest – all violently anti-establishment. Present were those not in the War, who were politically aggressive and desperate in the face of what the supposedly civilized Christian western world was becoming. At first excited by the notion of a renewal of art, "which is right now the only thing in itself accomplished" (Tzara, Dada 1, July 1917) Dada was to become more radical, more anti-art in Tzara's Manifesto (Dada 3, December 1918). This work overwhelmed Breton, he felt he had found in Tzara the reincarnation of Vaché.

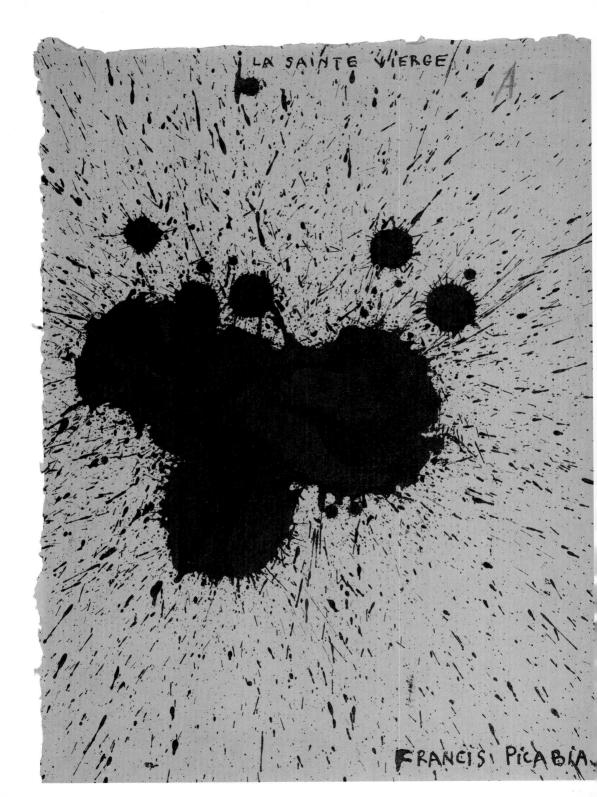

Previous page: Francis Picabia

The Holy Virgin,
1920, ink on paper,
bibliothèque littéraire Jacques Doucet, Paris.

'Didn't Dada's nihilism, denouncing the 'blue-horizon'society (World War I veterans, who wore blue) of the times, add a politically anarchistic dimension to the new poetry, thereby becoming "the development of a protest?" Would Surrealism simply become a kind or warmed over Dada? Along with Marguerite Bonnet and Maurice Nadeau, among others, I find it impossible to adhere to Michel Sanouillet's affirmation in Dada à Paris (Pauvert, 1965), that "Surrealism is Dada without the humor" (p. 432), or indeed, that it was to be "the French version of Dada" (p. 420). First of all, because Dada is not funny, it has nothing to do with the ambient humor of the day. Secondly, the movement that would soon be called Surrealist, tying an experimental spirit with the need for contest, not only was born long before the explosion of Dada in Paris – in an historical context that had absolutely nothing to do with Zurich - but still completely ridiculed the France's "national genius" to which Michel Sanouillet referred (p. 425)...

Breton the stretcher-bearer was profoundly moved by the paranoid delirium of a wounded soldier, the memory of which would remain with him throughout life. His only means of coming to terms with the barbarous aspect of war, would be in a spirit of experi-

mentation and of care, the spirit Freud, (whom Breton would meet in 1921 in Vienna - encounter for that matter barely successful), a medical spirit foreign to Dada (Tzara had always hated the Freudian school). There was no question of Breton conferring a quasimystical dimension to the revolt, nor sharing in Tzara's motto: "Severe necessity without discipline or morality, and let's spit upon humanity." (Preface to La Première Aventure céleste de M. Antipyrine [The First Celestial Adventure of Monsieur Antipyrine], the beginning of the "Dada Collection" 1916). Breton had been dizzied by the haughty despair of Jacques Vaché who committed suicide in 1919 by an overdose of opium - and this shared despair couldn't bring Breton to allow a public fuss preventing concentrated listening to an inner message. "Without discipline, nor morality?" No doubt. This was to be Surrealism's message, and around 1912-13 Breton was reading anarchist newspapers. But the poet himself was to maintain a very strict personnel discipline in order to proceed from fabricated poetry to "automatic writing." As for "spitting upon humanity" Tzara himself, a future Surrealist before later adhering to the Communist Party, might have simply seen this as a rather empty metaphor.

Bulletin Dada n°6, 1920, Private Collection.

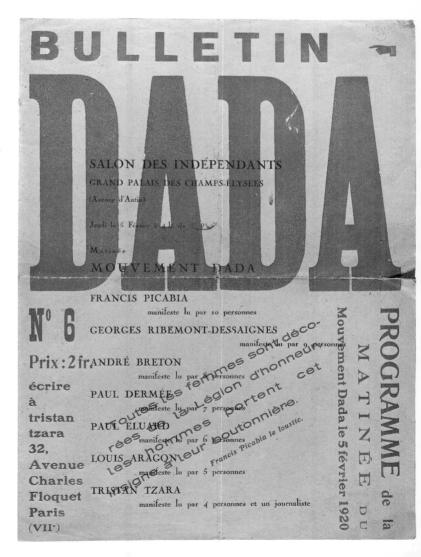

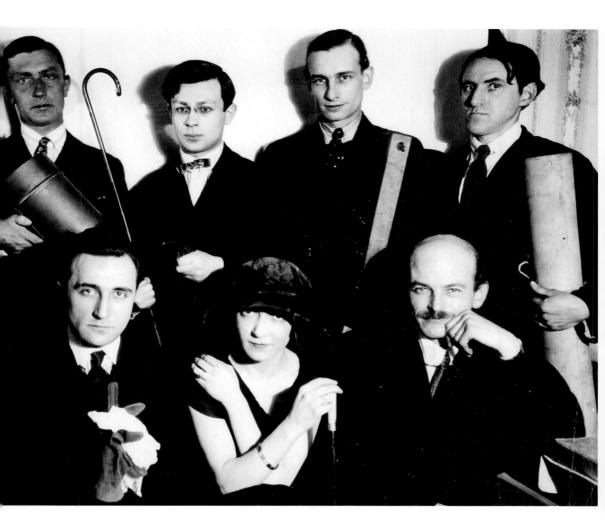

Man Ray

The Dada Group,

Standing, left to right: P. Chadourne, T. Tzara, Ph. Soupault, S. Chadourne.

Seated, left to right: P. Éluard with the photo of Man Ray, J. Rigaut, Mrs Soupault, G. Ribemont-Dessaignes.

About 1922, collage of two gelatin silver prints,

centre Pompidou-MNAM-CCI, Paris.

Surrealist Group in Saint-Julien-le-Pauvre, 1920. Left to right: Crotti, d'Esparliès, Breton, Rigaud, Éluard, Ribemont-Dessaignes, Péret, Fraenckel, Aragon, Tzara and Soupault, bibliothèque littéraire Jacques Doucet, Paris.

The din of the Dada meetings in Paris had, as a major effect, the attraction of young artists and poets in search of an identity to the rising Surrealist avantgarde. Benjamin Péret for example, joined the Dadaists immediately upon being discharged. Max Ernst arrived, Paul Éluard was there... Terrific pranks were imagined, for example: the public was invited to a Bach concert, a hullabaloo greeted them. "On stage, we beat on the keys, on boxes to make music, until the audience protested, went crazy." (Georges Hugnet, "L'esprit Dada dans la peinture" Cahiers d'art, 1932-1934). Sarcastic and incongruous behavior such as getting undressed on stage or speaking all at once, they bet they could empty out a hall in less than twenty minutes, and they did. The first "Lundi" (Monday) organized by the review Littérature (a review founded in 1920, where one found the names of André Gide, Paul Valéry, Léon-Paul Fargue, Éluard, Aragon, Breton, etc...) – just as Stéphane Mallarmé held his "Mardis" (Tuesdays) among friends - was a major event, a sort of publicity; the Dadaists proposed the replacement of art, by "slogans". And Dada was launched in Paris.

Previous pages:

Francis Picabia

Girl Born Motherless, 1916–1917, gouache on paper, Scottish National Gallery of Modern Art, Edimb

Tristan Tzara

A Night of Chess,

Dummy for the review 391 n° 6,
bibliothèque littéraire Jacques Doucet, Paris.

Was it really all that funny? It was seriously a question of ridiculing art. In Germany, the Weimar Republic was shaky, and the death of Karl Liebknecht and Rosa Luxemburg marked the end of the Spartakist movement (1919) - during an art exhibition in Berlin in 1920, had been proclaimed, "Art is dead" and "Dada is political". Richard Huelsenbeck and Raoul Haussmann, the organizers of this manifestation which had drawn crowds, soon settled down andjoined the German Communist Party. Baargheld, a banker's son, founded the review Die Schammade in 1919 in Cologne. Then the review Ventilator, with Max Ernst, Hans Arp and the members of Littérature, plus Tristan Tzara and Francis Picabia, organized an "exposition à scandale" in 1920. (One entered through the toilets, where a young communicant read licentious poems while Saint Theresa showed her black stockings...) The Surrealists applauded these novelties, but in fact, anticlericalism, or religious protest were a French tradition,

going back at least to the Symbolists Mossa and Odilon Redon at the end of the 19th century. Clovis Trouille, discovered by Breton at the Salon des surindépendants in 1936, painted his first canvasses such as Le Palais des merveilles in 1907. The works to come - La Sainte Vierge, by Picabia, a spirt of ink; films by Dali and Buñuel, notably; poems by Péret, surely the most obsessionally anti-clerical of the Surrealist poets; and Breton's famous formula, "God is a Pig" (in Le Surréalisme et la Peinture, Gallimard, 1965, p. 10) - all demonstrate that the Surrealists'anti-Christian attitude owed more to Lautréamont's visionary, rhapsodic prose, or to Sade's eroticism (they were to be the only ones to defend him in France in the thirties), than to funny but ultimately vacuous performances. Agitation isn't enough. One has to get down to an act. Does anyone remember that Rimbaud scribbled "Death to God" on a church? It's only his work that remains, and that continues to have an effect.

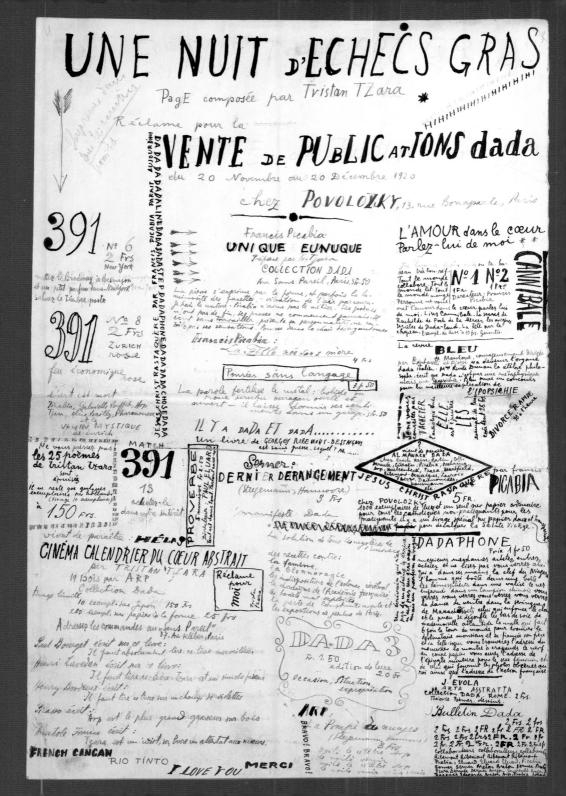

Dada Exhibition at the Montaigne Gallery, Paris, 1921.

To the anti-clerical tradition was added that of hatred for the bourgeois, strong since Baudelaire. Surrealism wouldn't have needed Dada to take up the flame. They furthered the debate by denouncing any expression of a sense of belonging to a place or cultural entity. During the "Barrès Trial" (May 1921), they attacked the reasoning of the do-gooders — this was the pamphlet incriminating Anatole France *Un cadavre* (a corpse), handed out at his funeral in 1924...

Then there was the temptation of joining the political struggle of the proletariat... The Surrealists were, in fact, all members of the bourgeoisie, having "betrayed their class" on purpose.

Clovis Trouille

The Palace of Wonders, 1907/1927/1960, oil on canvas, Private Collection.

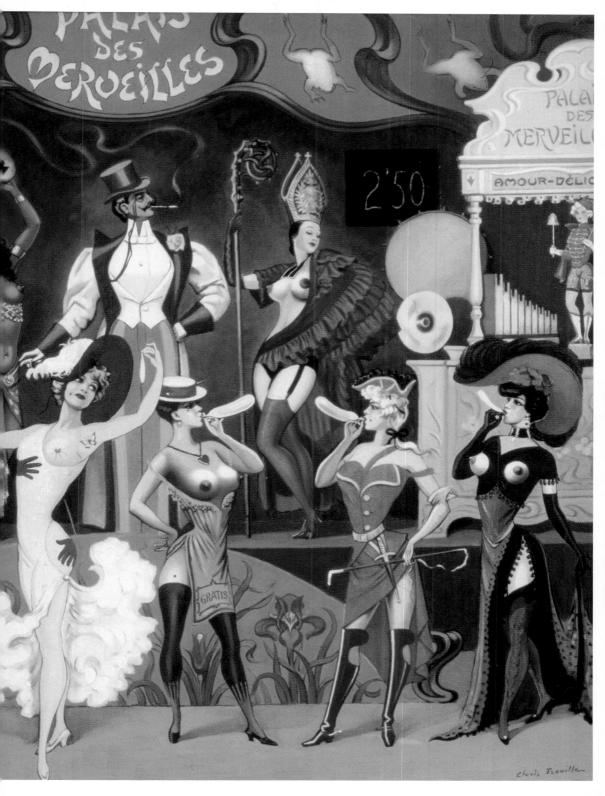

It was in regard to Picasso's decor for Les Mamelles de Tyrésias (The Breasts of Tyresias), a "Surrealist drama" by Guillaume Apollinaire (1917), that the word Surréalisme first appeared publicly. The poet had created it a short time before to describe the stage curtain Picasso had made for the review Parade, by Jean Cocteau and Erik Satie. By adopting the word, Breton was paying homage to Guillaume Apollinaire, about whom he would write, "To have known him was a blessing." Another blessing: the example of Marcel Duchamp. The Surrealists had certainly seen examples of breaking-away and artistic freedom since ruptures at the end of the 19th century - precursors such as Gustav Klimt, Wassily Kandinsky, Pablo Picasso, Paul Klee, Marc Chagall or Giorgio De Chirico. But Duchamp went beyond painting with his readymades, such as the famous porcelain urinal, presented upside down, entitled Fountain. He seduced the Surrealists

not only by putting a mustache on the Mona Lisa, which was subtitled *L.H.O.O.Q.* ("Elle a chaud au cul"/ "she has a hot ass"), but by leaving his *Grand Verre*, *La mariée mise à nu par ses célibitaires, même* (The Large Glass, the Bride Stripped Bare by Her Bachelors,

Even) unfinished in 1922. Example to follow?

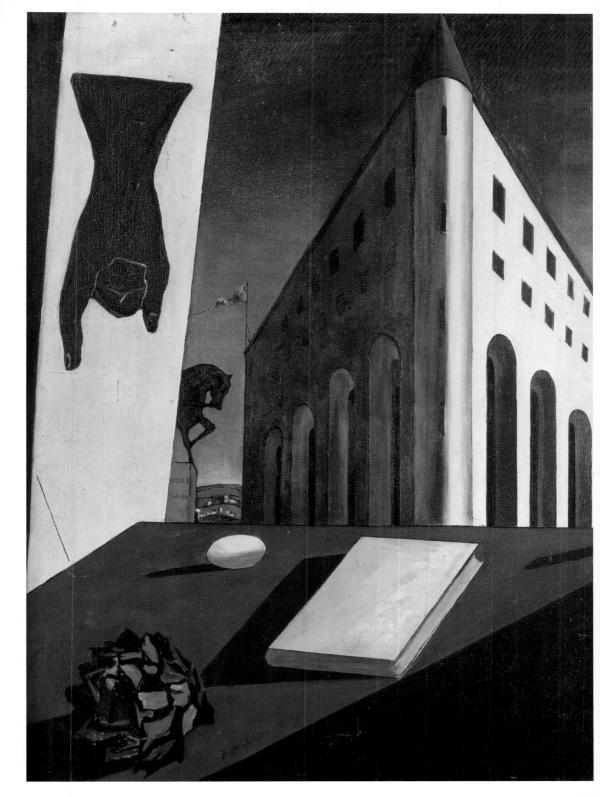

TABLEAU DADA par MARCEL DUCHAMP

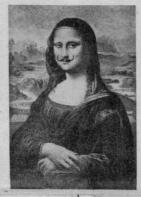

DADA Manifeste

Les cubistes veulent couvrir Dada de neige ; ça vous étonne mais c'est ainsi, ils veulent vider la neige de leur pipe pour recouvrir Dada.

Tu en es sûr ?

Parlaitement, les faits sont révélés par des bouches grotesques.

Ils pensent que Dada peut les empêcher de pratiquer ce commerce odieux : Vendre de l'art très cher.

L'art vaut plus cher que le saucisson, plus cher que les femmes, plus cher que tout.

L'art est visible comme Dieu! (voir Saint-Sulpice).

L'art est un produit pharmaceutique pour imbéciles.

Les tables tournent grâce à l'esprit ; les tableaux et autres œuvres d'art sont comme les tables coffres-forts, l'esprit est dedans et devient de plus en plus génial suivant les prix de salles de ventes.

Comédie, comédie, comédie, comédie, comédie, mes chers amis.

Les marchands n'aiment pas la peinture, ils connaissent le mystère de l'esprit...

Achetez les reproductions des autographes.

Ne soyez donc pas snobs, vous ne serez pas moins intelligents parce que le voisin possèdera une chose semblable à

Plus de chiures de mouches sur les murs.

Il y en aura tout de même, c'est évident, mais un peu moins.

Dada bien certainement va être de plus en plus détesté, son coupe-file lui permettant de couper les processions en chantant " Viens Poupoule ", quel sacrilège !!!

Le cubisme représente la disette des idées.

Ils ont cubé les tableaux des primitifs, cubé les sculptures nègres, cubé les violons, cubé les guitares, cubé les journaux illustrés, cubé la merde et les profils de jeunes filles, maintenant il faut cuber de l'argent !!!

Dada, lui, ne veut rien, rien, rien, il fait quelque chose pour que le public dise : "nous ne comprenons rien, rien, rien, rien" "Les Dadaistes ne sont rien, rien, rien, bien certainement ils n'arriveront à rien, rien, rien '

Francis PICABIA

qui ne sait rien, rien, rien.

Previous page:
Giorgio De Chirico
Spring in Turin,

spring in Iurin, 1914, oil on canvas, Private Collection.

Revue 391 n°8
February 1919,
in which is reproduced a painting by Marcel Duchamp,
Mona Lisa L.H.O.O.Q.,
bibliothèque littéraire Jacques Doucet, Paris.

During the course of a secret party, decisive for their future, Breton and Soupault swore never to make a career out of literature. Since their discharges in 1919, Breton and Aragon had ardently pursued the non-pursuit of a career, to the dismay of their families who hoped they would enter the medical profession. They didn't do anti-art, but developed creative life as a new "art de vivre", in total contrast with the fatuity of the pohètes.

In fact, it was at the time of the Barrès trial that Breton and Tzara angrily went their separate ways. There was a level of philosophical seriousness around the Barrès trial about which Dada cared little. As early as 1922, "It's with a certain relief that Breton and his friends distanced themselves from Dadaism" (Maurice Nadeau, *Histoire du surréalisme*, p. 54). Breton realized that a break was necessary, even with professionals

at breaking-up! He proclaimed:

"Drop everything. Drop Dada. Drop your wife. Drop your mistress. Drop your hopes and your fears. Conceive your children by the side of the road. Drop the prey for obscurity. Drop your need for a comfortable life, that which is offered for a secure future. Get on the road." [In Les Pas perdus.]

Should one associate the surprising disappearance of Éluard in 1924 with the doctrine "Drop everything"? He left, telling no one, and it was from Singapore that he telephoned Gala and Ernst (who were at the time having an affair, accepted so it seems, by Éluard) to come and get him. They followed as quickly as possible; Gala brought back Paul and Ernst returned on his own. The friendship between Ernst and Éluard was always to remain steadfast.

Wassily Kandinsky

Painting with Black Arch, 1912, oil on canvas, centre Pompidou-MNAM-CCI, Paris.

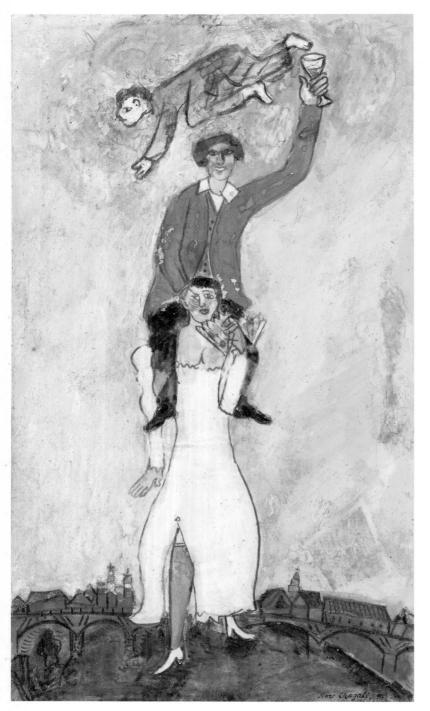

Marc Chagall

Double Portrait of a Glass of Wine,
1917, pencil and watercolor on the back
of a page printed in cyrillic,
centre Pompidou-MNAM-CCI, Paris.

Giorgio De Chirico

Melancolia, 1912, oil on canvas, Estorick Foundation, London.

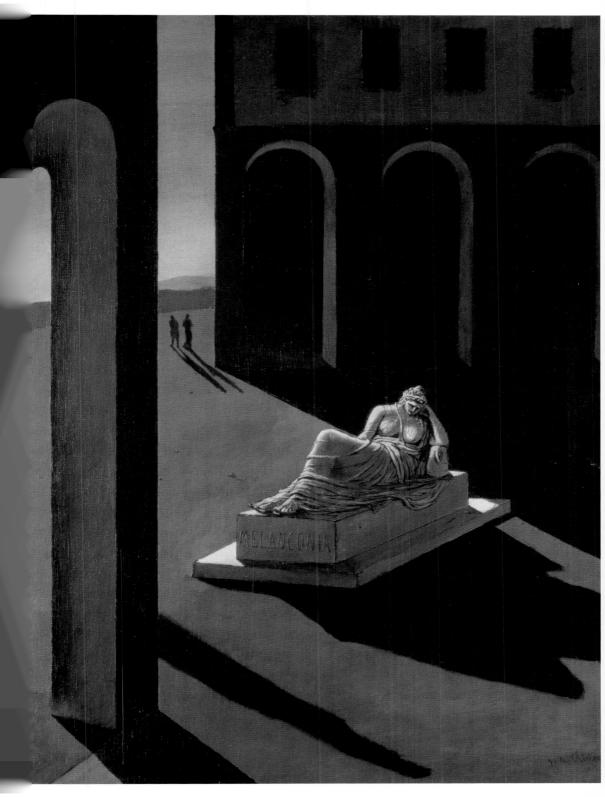

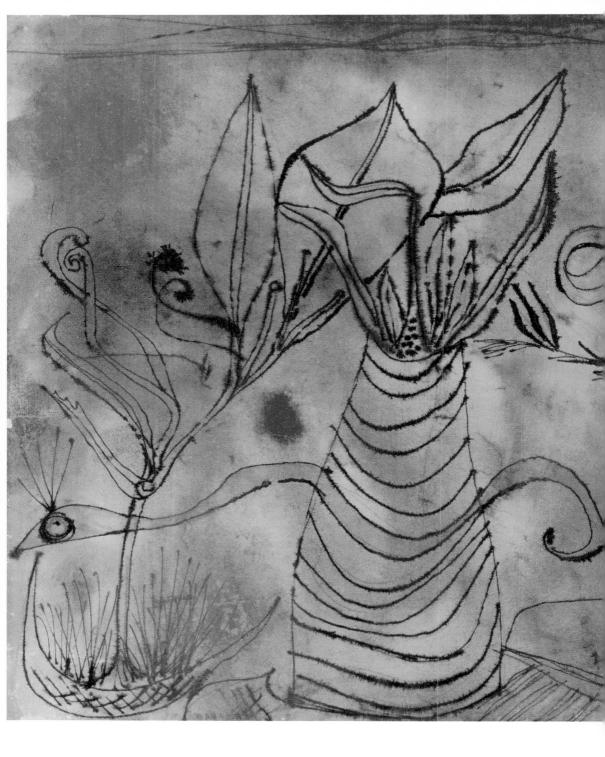

Paul Klee

Still–Life with Serpent, 1924, ink and gouache on paper, Galleria Internazionale d'Arte Moderna, Venice.

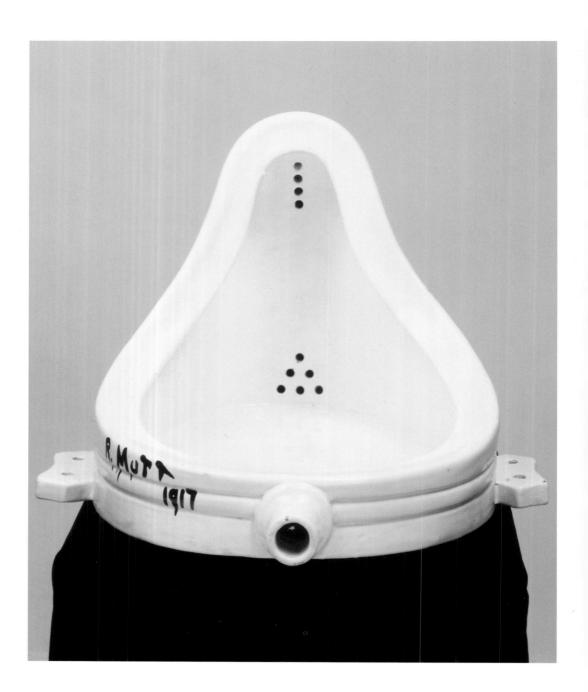

Marcel Duchamp

Fountain,

I917/1964, the original made in New York in 1917, porcelain, centre Pompidou-MNAM-CCI, Paris.

Le Monde entier parle du

MANIFESTE DU SURRÉALISME

POISSON SOLUBLE

par

ANDRÉ BRETON

Qu'est-ce que le Surréalisme?

KRA, ÉDITEUR 6. Rue Blanche

Le volume: 7 fr. 50

LA RÉVOLUTION SURRÉALISTE

SOMMA

ves : Georgio de Chirico, André Breton,
Renée Gauthier.

Textes surréalistes :

Textes surréalistes :

arcel Noll, Robert Desnos, Benjamin Péret, Georges Molkine, Paul Eluard, J.-A. Boiffard, S. B., Max Morise, Louis Aragon, Francis Gérard. 4. céveur pami les mursilles : Pierre Reverdy. Max Morise, Joseph Deltei Francis Gérard, etc. Notes. Illustrations: Photos Man Ra Max Morise, G. de Chirico, Max

Dépositaire général : Librairie GALLIM.

LE NUMÉRO: France: 4 francs Étranger: 5 france

Cover of La Révolution surréaliste n°1, Ist December 1924.

André Breton and Jacqueline Lamba at the Surrealist Exhibition, London, 1936, bibliothèque littéraire Jacques Doucet, Paris.

Pablo Picasso

Woman in a Blouse in Armchair, 1913, oil on canvas, Collection Ingeborg Pudelko, Florence.

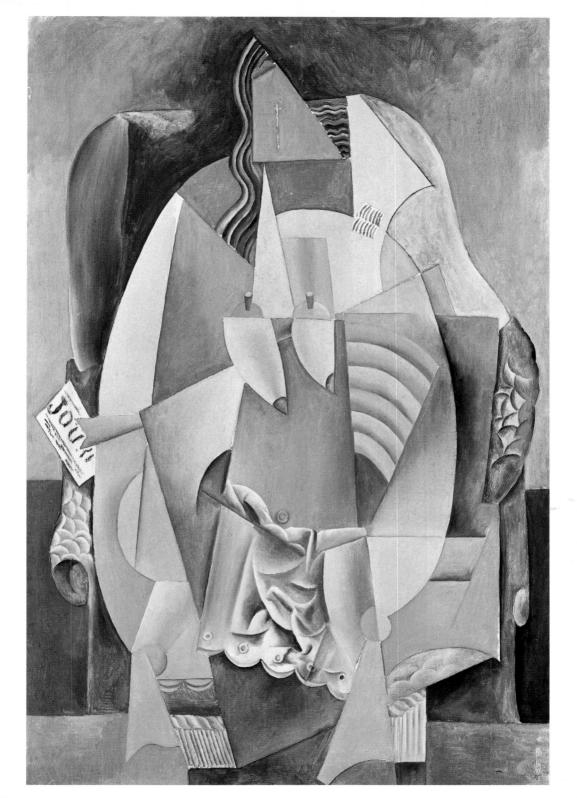

These young people hadn't a cent. However they weren't alone. While Aragon had been the cultural advisor [1922-26] to a rich fashion designer, Jacques Doucet, also a collector of manuscripts, Breton had, thanks to Paul Valéry, found a job as a corrector at the N. R. F. (Nouvelle Revue Française). He would read Proust's prose out loud, (so close to his own). Is this when he became thoroughly disgusted with the novel once and for all? The review Littérature survived the Dada storm, and continued from March 1922 until June 1924. It remained eclectic and confused; Breton was "bored there".

During this time, chance meetings continued to be fortuitous. On Rue Blomet, not far from the Bal Nègre, André Masson rented a studio in 1922 and found himself living next door to Joan Miró. Antonin Artaud, Louis Aragon, Michel Leiris and Georges Limbour were regulars at the atelier, as well as André Masson. Breton bought Masson's *Les Quatre éléments* (1923), and he in turn introduced the Catalan Joan Miró to Breton. In 1923, Yves Tanguy and Jacques Prévert, having met at a party in Lunéville, lived at 52 Rue du Château, in a locale that Marcel Duhamel rented for them.

New arrivals swarmed around Breton - the actor. Antonin Artaud, Maxime Alexandre, Georges Limbour and André Masson (who passed directly from his Cubist painting to "automatic drawing" skipping Dada completely) Joseph Delteil, J. A. Boiffard, Jean Carrive, Francis Gérard, Pierre Naville, (who's future lay in sociology and Trotskyism), Marcel Noll, Georges Malkine, etc. These "friends" met in cafés, which would remain, throughout the movement, as privileged places of discussion and debate. Breton was going on 30? Handsome, somewhat well-padded, rather solemn, speaking rarely, never laughing, but warm, some would say solar. Jacques Prévert would write that Breton's disciples "loved him like a woman..." This, however, had nothing to do with the latent homosexuality found in certain military or ecclesiastic gurus. Breton, loved by women, always idolized them. The Surrealists openly berated Paul Claudel and later Ehrenbourg, who had dared to label their activity as "pédérastique"...

It has been said that Surrealism was not particularly feminist. For them, certainly women were not the

bellicose amazons depicted by the Futurists, but rather, according to Baudelaire's formula, beings that projected on life "the most shadow and the most light." Or beings such as the magician elicited by Breton in Arcane 17 (1946), those of Gustave Moreau, Symbolist painter whose pictures had enchanted the adolescence of the same André Breton. This in itself was a considerable achievement considering the macho attitudes, not only of Dada, but also of Freud and even of the revolutionary parties, not to mention the Catholic church. Frequently quoting Rimbaud, "When woman's infinite servitude will be broken... when she will finally live by and for herself, man – up until now abominable - having given her dismissal, she will be a poet, she also." (Letter to Paul Demeny, 5 May 1871). The Surrealists stated along with Breton that "In Surrealism, woman will have been loved and celebrated like the great promise, one that remains, after having been kept." (Surréalisme dans ses œuvres vives, Surrealism in its Vivid Works, 1962). There were many prominent women artists and poets at the time - Maria Toyen, Léonora Carrington, Dorothea Tanning or Joyce Mansour...

In fact, for years, through disputes and reconciliation's, the Surrealists were linked by a sort of passionate friendship, guided by a shared artistic mission.

The important thing was in the "interventions" the investigations and what must rightly be called creation. The break with Dada had been definitive after the failure of the "Congrès pour l'établissement et les directives de l'esprit moderne" (Congress for the Establishment and the Directives of the Modern Spirit, 1922). This pompous title, certainly indicative of a "revolutionary" seriousness, was to qualify the group for years. The "Bureau de recherches surréalistes" (Office for Surrealist Experimentation) was created, and the review La Révolution surréaliste, in which the first number dated 1st December 1924 contained dreams and "Surrealist texts" by Louis Aragon, Jacques Baron, Marcel Noll, Robert Desnos, Benjamin Péret, Georges Malkine, Paul Éluard and Philippe Soupault, etc. The cohesion of the group was being reinforced. The publishing house Kra published the Manifesto of Surrealism. The movement was well underway.

André Masson

The Four Elements, 1923/1924, oil on canvas, centre Pompidou-MNAM-CCI, Paris.

PLENITUDE

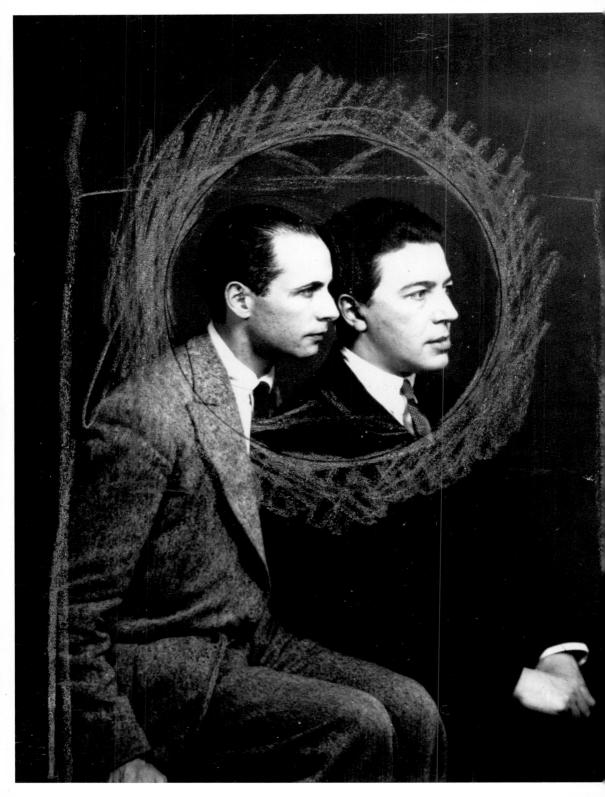

The pamphlet

calling Anatole France *Un cadavre* (a cadaver) unleashed verbal violence among the Surrealists.

Aragon had said:

"Some days, I wish I had an eraser to erase the vileness of humanity." But he also would say in passing:

"I somehow like the fact that the man of letters salutes both the tapir Morras and Moscow gone senile..."

This insult was to create a rift between the Surrealists and Jean Bernier, director of the Communist review *Clarté*.

Louis Aragon and André Breton, About 1925, gelatin silver print.

realisite hold

It was simply that the Surrealists conceived of the revolution only in terms of ideas. Aragon — who one day would become a member of the French Communist Party — responded to Bernier's article, notably, that the October 1917 Revolution "on an ideological level, is at the most a vague ministerial crisis." A declaration 25 June 1925 stated, "Surrealism... is a cry from the mind that turns upon itself, determined to desperately crush all obstacles... And if need be, with real hammers." One could have imagined in this last phrase some indication of social commitment, but for the moment the Surrealist revolution remained in the mind as a source of inspiration.

Another document cited by Maurice Nadeau stated: "The idea of any sort of Surrealist revolution(...) aims to create a new form of mysticism." These atheists certainly had religious souls.

Previous page:

Max Ernst

Nude Woman between Two Monsters with Birds'Heads, Engraving, from A Week of Happiness or the seven Capital Elements, 1932. Private Collection.

In fact, discussion moved along at a good pace within the group. Their nihilism put the Surrealists before the choice of living or not, facing the tragedy of existence. In the first issue of La Révolution surréaliste, along with accounts of dreams, there was a column where all recent suicide cases were tallied, along the startingup of a survey "Is suicide a solution?" The shade of Vaché continued to hover over Surrealist feelings, but the young people were too vigorous and too alive, to answer affirmatively to the survey. In fact, there were very few suicides among the Surrealists about this time – in spite of the repercussions among them over Mayakovski's suicide. (This would not be the case after the Second World War). Only René Crevel - who had written in Détours (Gallimard, 1924): "A cup of herbal tea on the gas stove, the window tightly shut, I turn on the gas; I forget to light the match..." was found dead, one morning in 1935, next to his stove with the gas on...

The creativity of the Surrealist poets and painters was intense. Coming out: Pierre Naville's "automatic" text, Les Reines de la main gauche, L'Ombilic des limbes, by Antonin Artaud, Deuil pour deuil, by Robert Desnos, Simulacres by Michel Leiris and André Masson,

Proverbes mis au goût du jour, by Paul Éluard and Benjamin Péret, Mourir de ne pas mourir, by Éluard, Les Mystères de l'amour, by Roger Vitrac and Le Libertinage, by Louis Aragon.

In Germany Max Ernst had made his first collages in which old engravings became a sort of visual poem, very different from Picasso's "papiers collés" or Dada's "photomontages". This was one of Surrealism's better inventions. To be convinced, one only needs to look at such a selection published as *Une semaine de bonté* ou *Les Sept Élements capitaux* (A Week of Happiness or the Seven Capital Elements, Jeanne Bucher, 1934). Ernst had met Breton in the Tyrol and allowed himself to be drawn into Surrealism, after having flirted with Dada. In 1925, he invented *frottages* (rubbings), soon to be assembled in the album *Histoire naturelle* (Jeanne Bucher, 1926). He recounted his discovery in an key text:

"Beginning with a childhood memory in which a mahogany panel across from my bed had created an optical illusion in my half-sleep, and finding myself one rainy day in an inn at the seashore, I was struck by the way in which the wooden floor, worn to the grain by

a thousand washings, became an obsession of my distorted view. I decided then to try to find the meaning of this obsession, and in order to aid my meditative and hallucinatory faculties, I made a series of drawings from the planks by posing on them, randomly, sheets of paper which I then undertook to rub with a lead pencil."

All we find in this text is worthy of the guidelines of the *First Manifesto of Surrealism* — visions in a state of half-sleep, obsession, hallucinatory faculties, the work of chance, and technical invention.

Other references to suggestive chance took place over the years in this group where "Surrealist games" were played. For example, the game of "petits papiers" in which each person writes or draws something before hiding what has been written, so that the following person continues by chance. The game produced: "the exquisite corpse will drink the new wine" hence the name, "Jeu du cadavre exquis". In the game "Questions and Answers" one would say, "I have a question;" the other, "I have an answer:" then both would announce what they had to say. This produced some interesting results: "What is suicide? — Several deafening rings." Or, "What is physical love? — It is half of pleasure." In the review Variété (Surrealist issue,

1929) one finds the game, "If/When" which is played around a table, each person writing a sentence beginning with "if" and one beginning with "when." An typical outcome: "If there were no guillotines... - wasps would take off their corsets." In spite of the mental stimulation provided by these "games" and the abundance of works produced, there were tensions within the group at this time, 1924-1925. Pierre Naville, a keen politician, questioned the very existence of Surrealist painting and wondered if the association of the word revolutionary with the Surrealist movement was anything other than an embellishment. What could this "mysticism" mean other than a revival of old superstitions? – In N° 2 of La Révolution surréaliste there is an attempt to overcome these questions by a cry of a moral nature: "Open the prisons. Dismiss the army. There are no common law crimes."

This text, while strongly utopian, ends with these words which are still relevant: "We learned without surprise that in America at Christmas, several executions had been suspended *because the prisoners had nice voices.*" And now that they've sung, they might as well die, to carry out the exercise. In these cubicles, on the electric chairs, the dying wait — Would you let them be killed?"

Max Ernst

Frottages,

from the album Histoire naturelle, 1926.

One should not be surprised by this libertarian outcry. It was to be just one of the trademarks of all the Surrealist protests - which in no way contradicts the notion of spiritual revolt. Mysticism rejoins violence in two Addresses (N° 3), one directed to the Pope. the other to the Dalaï Lama. To the brutality of "Beware! Pope, dog" on one side, the other answers, "We are your very faithful servants, oh great Lama... Oh acceptable Pope, Oh Pope of the true spirit!" Logic and reason, so-called Western, are also denounced in a Lettre aux écoles du Bouddha (Letter to the Schools of Buddha), in which one suspects Artaud's hand. Artaud, the director of the Centre de recherches surréalistes (Center for Surrealist Experimentation), would find in Balinese theater a source of inspiration for his "théâtre de la cruauté" (Theater of Cruality).

Desnos was also fascinated by the Orient – all the Surrealists were – as N° 3 of their review demonstrates.

Nothing like a few public scandals to consolidate a group – thus the sabotage of the Banquet Saint-Pol Roux. The "magnificent" (Catholic) poet – much admired by the Surrealists for his dazzling rhetoric – was being honored at the Closerie des Lilas in July 1925. The Surrealists disliked some of the guests.

Madame Rachilde having loudly asserted that "No Frenchwoman could marry a German" Breton stood up and solemnly informed the woman that she had just insulted his friend Max Ernst, present at the banquet. Tumult followed with cries of "Long live Germany!" Philippe Soupault, hanging from the chandelier, swept the entire table. Saint-Pol Roux whined in a corner. Fists were flying. The police arrived and kicked out everyone. Michel Leiris, leaning out the window screamed "Down with France!" The crowd outside dared him to come down. He came down, and had his face smashed in before being manhandled at the police station. Later, texts of this major writer and ethnologist would be found in schoolbooks...

The press unanimously condemned these Surrealist hoodlums. At the same time they published une *Lettre ouverte à Paul Claudel, ambasadeur de France* (An Open Letter to Paul Claudel, French Ambassador) — in which one could find jewels such as: "We declare having discovered treason and all that in one way or another could endanger state security, which is finally more compatible with poetry than the sale of 'large quantities of lard' for the benefit of a nation of pigs and dogs..."

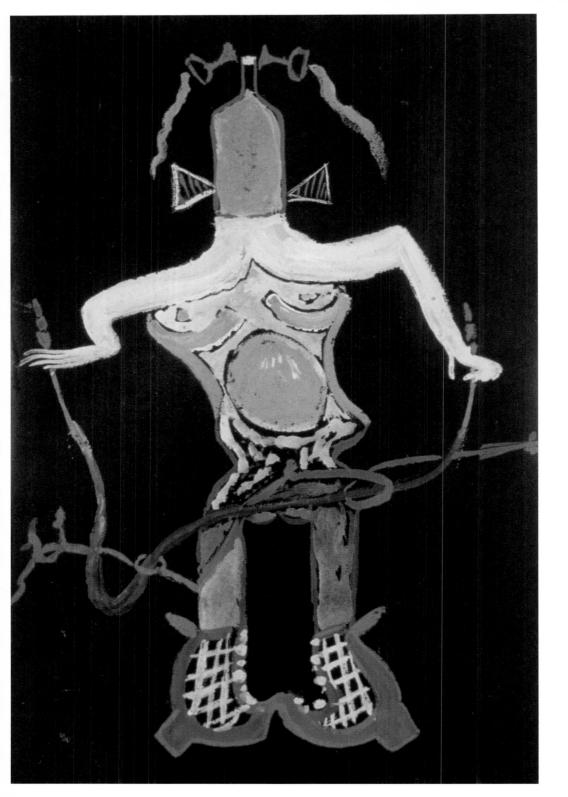

André Breton, Pierre Unik, Louis Aragon and C. Susanne Exquisite Corpse, 1929, gouache, Private Collection.

L'Action Française, a royalist newspaper of "nationalisme intégral" (militant nationalism), called for the imprisonment of the Surrealists – all the more so given that in a gloomy political context, Abd el-Krim in Morocco had started the "War of the Rif". War over and over again! The Surrealists'political conscience was awakened by this colonial affair, and they then rallied around Clarté. Old differences were forgotten and they joined the "comrades" of the French Communist Party. They published a manifesto La Révolution d'abord et toujours (The Revolution Now and Forever). The signatories declared that the idea of national identity was an "concept bestial" (brutal concept), that they were "in revolt against history" that they admired Asia and called for "the Mongols, to camp on our sites". They added: "We will never accept to put on the abject 'blue-horizon' cape - we are not utopians. We can only conceive of this revolution in social terms." Nearly ten years later, in 1934, Breton would note that this text, "ideologically rather confused" had nonetheless marked a considerable turning point. The Surrealists had let go of a certain

anti-rationalist idealism, and tried to advance to "reasoning" and materialist phase. However, along with this political statement was a "Lettre aux voyantes" (Letter to Clairvoyants) by Breton and a "Nouvelle lettre à moi-même" (New Letter to Myself), a dark, tortured work by Artaud. Later Artaud would publish (N° 8) "Lettre à la voyante" (Letter to the Clairvoyant) — "plus proche de moi que ma mère" (closer to me than my own mother). The clairvoyance of women, in the mystical sense, was one of Surrealism's principal values. In defending this position, the groundwork was laid for what would later be called the two level theory — the simultaneous adherence to political discipline imposed by a political party and the personnel freedom for experimentation and creativity...

For the moment, the Surrealists hoped to be able to act on both levels in spite of Naville's position, which demanded that a choice be made between subjective anarchy and dialectic materialism. Aragon, Breton, Éluard, Péret and Unik joined the Communist Party. Breton found himself in the gas unit...

the trabiante Sexual

Fortunately, Surrealism, as such, was in the course of transforming art, if not life itself, with works such as Le Paysan de Paris (The Peasant from Paris), by Aragon, Capitale de la douleur (The Capital of Grief), by Éluard, Nadja, by Breton and the famous Traité du Style (Treatise on Style), by Aragon (Gallimard, 1928). Masson fabricated his first sand paintings. The galerie surréaliste opened in Paris. Soupault and Artaud were excluded because of their refusal to become committed politically...

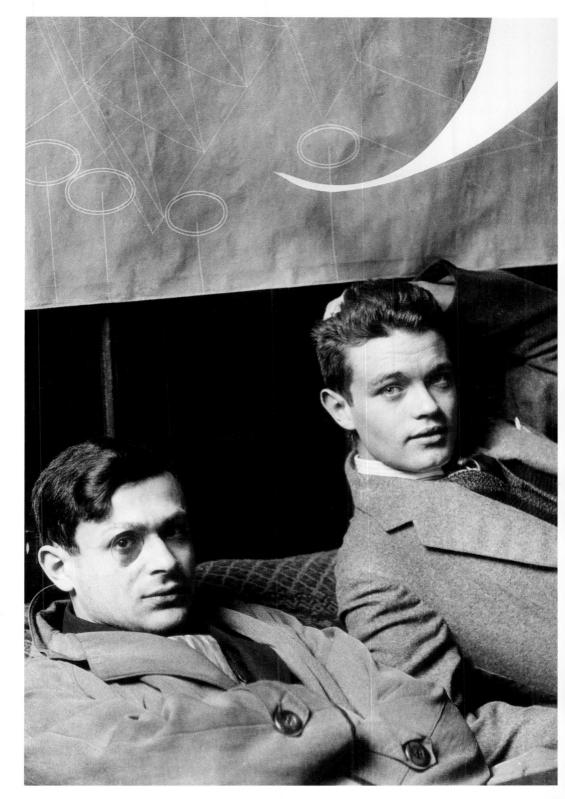

Previous page:

Man Ray

Tristan Tzara and René Crevel,
About 1928, silver salt print,
centre Pompidou-MNAM-CCI, Paris.

Let's name some of the great poems that have survived the test of time: in *Capitale de la douleur*, one can sense the suffering hidden beneath the celebration of love and woman:

"La Dame de Carreau" (The Queen of Diamonds)
Tout jeune, j'ai ouvert mes bras à la pureté. Ce ne
fut qu'un battement d'ailes au ciel de mon éternité,
qu'un battement de cœur amoureux qui bat dans
les poitrines conquises. Je ne pouvais plus tomber.
(As a young man, I opened my arms to purity.
It was only a flutter of wings in the sky of my
eternity, only the beating of a heart in love which beats
in won-over bosoms. I could no longer fall.)

Shortly after in *L'amour, la poésie* (1929), Éluard expanded his incantation of love to a cosmic dimension:

Je te l'ai dit pour les nuages
Je te l'ai dit pour l'arbre de la mer
Pour chaque vague pour les oiseaux dans les feuilles
Pour les cailloux du bruit
Pour les mains familières
Pour l'æil qui devient visage ou paysage
I told you in regard to the clouds
I told you in regard to the tree of the sea
For each wave, for the birds in the leaves

For the pebbles of noise

For the familiar hands
For the eye that becomes face or landscape

With Nadja, Breton wrote his only novel, which was in fact an essay. He had already published his autobiographical poem, "Tournesol" (Sunflower) in Clair de Terre (1923): "The lady traveler, crossing Les Halles at nightfall..." And here it's he who falls upon — Rue Lafayette, then Place Dauphine (which must surely be the sexual organ of Paris) — a mysterious woman, Nadja, of whom he asks himself on what inner abyss fell her slightest words. From the hôtel des Grands Hommes, Place du Panthéon, where Breton stayed, to the statue of Étienne Dolet, which created for him "an unbearable uneasiness". Breton listens to Nadja, and makes the tragic enter the supernatural:

"...I saw her fern-like eyes *open* one morning onto a world where the beating wings of immense hope could barely make out the other noises, which were the sounds of terror..."

In the meantime, polemics became enflamed with Artaud, who was to publish in 1929 L'Art et la mort (Art and Death), in which one could already sense the heartbreaking nuances that would distinguish him as the poet of physical misfortune as a category of the mind: "This flux, this nausea — it's here that begins the

Fire. The fire of tongues. The fire woven into tresses of tongues, in the reflection of the earth that opens like a belly in labor, with entrails of honey and sugar."

Artaud had already been excluded from the group when he founded the Alfred Jarry Theater, an extraordinary enterprise. He had responded to the manifesto Au grand jour (In Broad Daylight, 1927), that proposed social revolution in a rather severe pamphlet, À la grande nuit, ou le bluff surréaliste (To the Big Night, or the Surrealist Bluff). Thus, breaking-up. And in 1938, in the preface to Théâtre et son double (Theater and Its Double), he wrote this sentence, a declaration of his personnel vision of art and the world: "If there is still something infernal and veritably cursed in our times, it is the artistic lingering over form, instead of being like the victims of torture that are burned, who make the sign of the cross on their funeral pyres." (O.C., Gallimard, vol. IV, p. 14). The Surrealists never really liked the theatre. The breaking-up with Artaud was consummated during the presentation of The Dream Play by Strindberg, on 7 June 1928.

La Révolution surréaliste was doing brilliantly. The appearance of a defrocked priest lent a humorous note to N° 8. The priest wore his robe, garnered with a red carnation in order to show off with the hussies at the Dôme. He ended up accusing Breton of being the

devil's helper... In N° 11 (March 1928) the fiftieth anniversary of hysteria was celebrated (1878-1928), "the greatest poetic discovery of the end of the twentieth century" with the famous photos of Augustine de Charcot, during a seizure... In addition, it dedicated nine full pages to "Experiments in sexuality" the fruit of the group's discussions. What is remarkable in this text is its aspect of being both libertarian and limited at the same time. For example, Breton stands up against male homosexuality, which is not very libertarian, yet he demonstrates a certain freedom in his answer to the question:

"What does Breton think about sodomy between men and women?"

"Only the best."

"Have you already indulged in it?"

"Of course."

Once again we can conclude that in love, bodily freedom is in fact, spiritual freedom. This quest for truth within the meanders of physical love culminates in N° 12 (December 1929) with the famous enquiry "What sort of hope do you place in love?" This number opens with the Second Manifeste du surréalisme. A year earlier Le Surréalisme et la Peinture (Surrealism and Painting) was published. Let us examine the movement's relationship with visual arts.

Salutius Clubby

In the fourth issue of La Révolution surréaliste Breton began the series of articles that would figure in the 1928 publication, Le Surréalisme et la Peinture. In the third issue (April 1925), Naville had denied the existence of Surrealist painting: if one barters technique in the name of pure spontaneity, how can one really paint? Co-director of the review at the time, Naville decided that "Everyone knows that there is no Surrealist painting. Obviously, neither random freeflowing sketches, nor dream reproductions nor pure products of the imagination can qualify." Breton wasn't the slightest bit worried about this problem; his articles set out to prove that Surrealist painting truly existed. As of the second page of the review he clearly stated his point of view: "It is impossible for me to look at a painting without seeing it as a window. The first thing I want to know is, "What do you see through the window?" It must look upon some "outrageous spectacle" something marvelous.

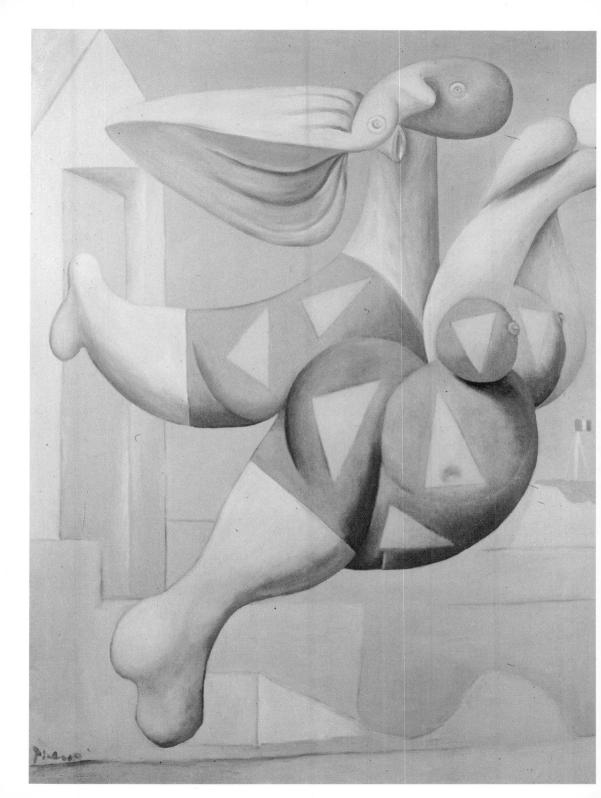

Previous page:
Pablo Picasso
Bather playing ball,
30 August 1932, oil on canvas,
Private Collection.

Picasso, (who participated in the 1925 Surrealist exhibition in the galerie Pierre) and Braque were warmly congratulated, whereas the precursors of the expressionist and Dada movements, were completely ignored. Francis Picabia was cited for his "Perfect lack of understanding of Surrealism." Breton brutally panned Giorgio De Chirico's new style: "What greater folly, than this man's, lost among the besiegers of the very city that he built, that he made impregnable." A diatribe against the relationship between painting and money followed. The Surrealists were in fact avid collectors and, far from rich, didn't hesitate to sell their works, sometimes even paintings that had been gifts. There was a market for Surrealist painting; the paradox was in making use of it, while all the time playing the game, whether through opening galleries or by brokering paintings on a second-hand market.

Max Ernst was one of the first to prove that Surrealist painting really existed. In his collages from 1918 and his paintings from 1921 – he was living in Saint-Brice near Paris at the time – to his "raclages" (scrapings) from 1927, Breton often mentioned numerous works reproduced here. Nick-named the "the Superior of the birds" Ernst left the Surrealist movement in 1942 having painted a canvas called, appropriately, Le Surréalisme et la Peinture. The painting rightly takes up Naville's arguments. A viscous monster sitting on a case containing artist's tools, draws automatic "abstract" forms with his tentacle-paint-brush. The forms bear no relation to his vague inner impulses.

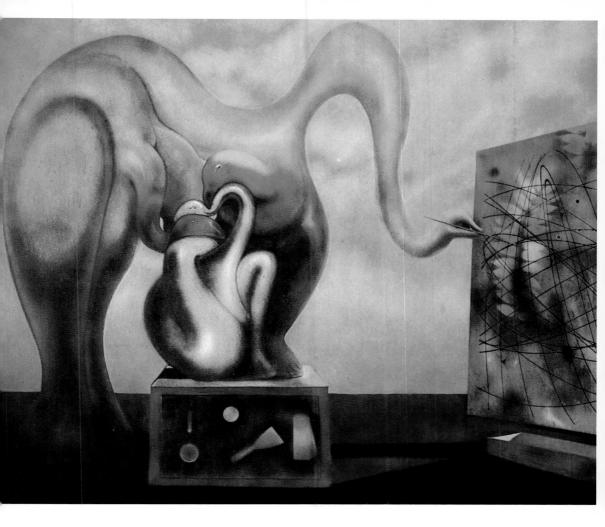

Surrealism and Painting, 1942, oil on canvas, Menil Collection, Houston.

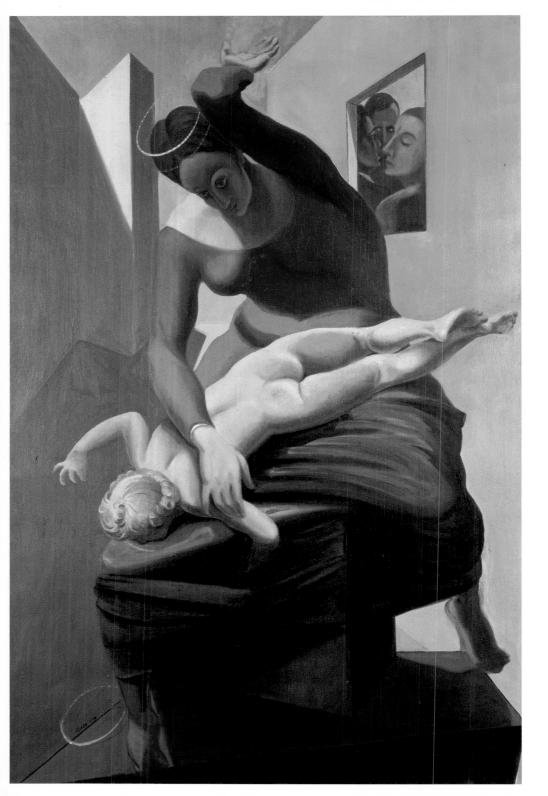

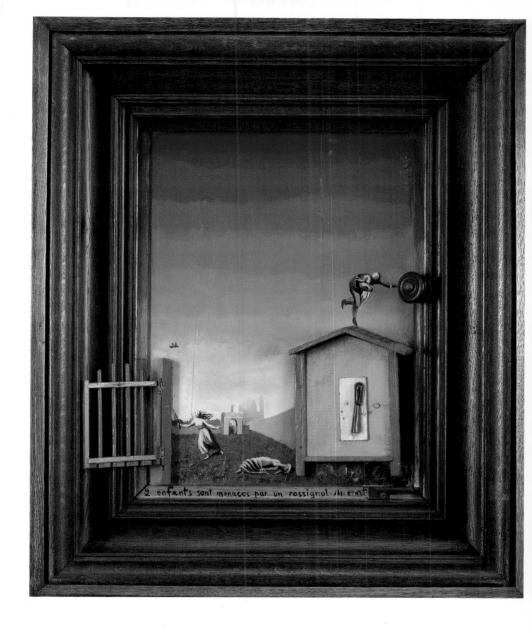

The Virgin Mary Punishing Baby before three Witnesses: A. B., P. E. and the author, 1928, oil on canvas, Ludwig Museum, Köln.

Max Ernst

Deux enfants sont menacés par un rossignol, 1924, oil on canvas, The Museum of Modern Art, Kay Sage Tanguy Fund, New York.

Vision provoked by the Nocturnal aspect of the porte Saint–Denis,
1927, oil on canvas,
Private Collection.

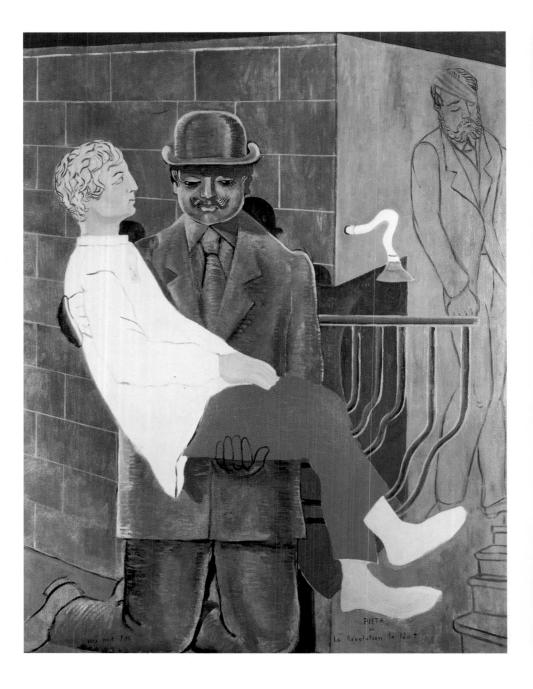

Pietà or Révolution at night, 1923, oil on canvas, Collection Penrose, London.

This symbolic self-portrait of the artist at work, as on a stage-set, presents a critical and pictorial awareness of the principles of Surrealist painting. It shows the image of a creative work, distorted by stylistics which are culturally founded and not "sauvage" (wild) in the sense Breton intended in the first sentence of his book: "L'œil existe à l'état sauvage" (The eye exists in a wild state). Was this wishful thinking, more than a observation — no eye exists in a wild state. In spite of this lucid satire, if remains that Max Ernst's painting is Surrealism itself.

Oedipus Rex, 1922, oil on canvas, Claude Herraint Collection, Paris.

André Masson

Automatic Drawing,
1925-1926, ink on paper,
centre Pompidou-MNAM-CCI, Paris.

Joan Miró, a Catalan, moved to Paris in 1920. First of all he was a realist meticulous painter who took no part in Parisian polemics. However, he quickly shed his traditional style with *Terre labourée* (Plowed Earth, 1923-1924) – the canvas becomes a space upon which objects are juxtaposed. The style is still angular, yet dreamlike. Miró lived on the Rue Blomet, and would soon become a part of the group. Under the influence of Paul Klee, his painting attained, according to Michel Leiris, "the understanding of emptiness". It was Miró who brought another Catalan to the group in 1929, Salvador Dali.

André Masson, another Rue Blomet artist, was trying to find a liquid "automatic" style in his drawing while his painting still tended towards Cubism. In 1927 he invented his sand pictures, perhaps as a way of reaching the same level of spontaneity that he had achieved in his drawings. Breton saw in Masson "the chemistry of intelligence" and would write in this regard in 1941: "The painter's hand is *tied* part and parcel to him..." In 1928 Masson illustrated Sade's *Justine*. More Surrealist than ever, he was nonetheless among those excluded from the *Second Manifeste du surréalisme*...

Joan Miró

Le Fou du Roi, 1926, oil on canvas, André Lefèvre Collection, Paris.

Following pages: Joan Miró Harlequin's Carnival,

1924-1925, oil on canvas, Albright Knox Art Gallery, Buffalo.

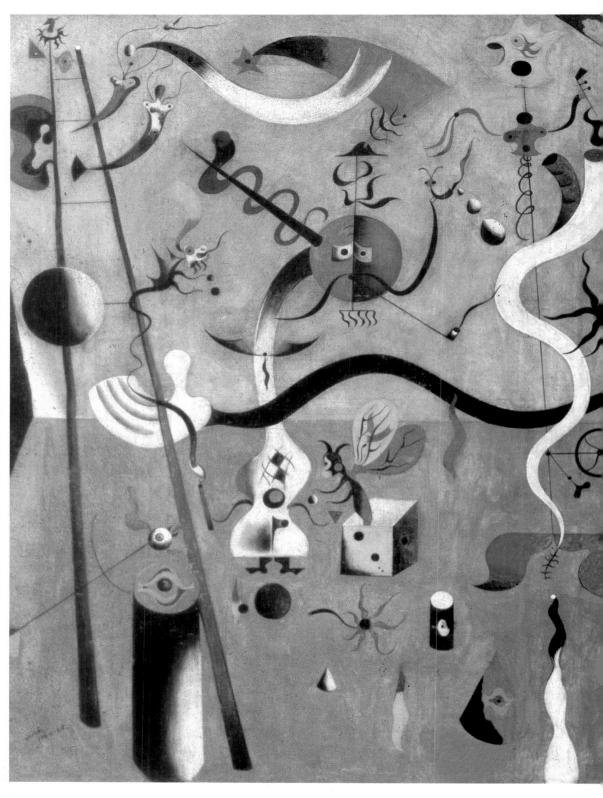

René Magritte

The Breast, 1961, oil on canvas, Private Collection.

René Magritte's name appears only at the end of the 1965 edition of Breton's book. And yet this enigmatic Belgian figurative painter of the absurd was all the same a major figure in pictorial Surrealism. The emotional shock he felt upon seeing De Chirico's canvases led him to paint his first Surrealist work, Le Jockey perdu (The Lost Jockey, 1925). He then produced one painting a day, and in 1928 met the Surrealists in Paris. Breton and Éluard encouraged him, but his first quarrel with Breton dates from 1929.

There the Belgian Surrealists were often at loggerheads with the French ones. It seems to me that Magritte's thematic material can be reduced to five leitmotifs: the great cold open spaces, the night interior, woman gazed upon, and metamorphosis, as a search for a surreal coming out of the depths, enlightened by the laws of absurdity. Magritte refuted Psychoanalysis, but a painting such as *La Poitrine* (The Bosom — a pile of empty houses) appears to evoke his mother's suicide. She had thrown herself into the Sambre River when he was fourteen. His thought processes, deliberately directed toward an *outside model*, would bring a philosophy of "looking" to Surrealism that would contradict Breton's dogma for "little reality."

René Magritte

The menaced Assassin, 1926, oil on canvas, The Museum of Modern Art, Kay Sage Tanguy Fund, New York.

Yves Tanguy

A great Painting which represents a Landscape, 1927, oil on canvas, Private Collection.

Yves Tanguy began to paint in 1924 after the scandal at the Banquet Saint-Pol Roux drew him to the Surrealists. He quickly found his niche in this world that would remain his own until his death in America in 1955. Breton spoke of the village Ys, hidden away along the Brittany coast, whatever — once the painter had plunged into his world of milky luminosity, he would never leave it.

Breton had great esteem for Hans Arp's sculpture in spite of the fact that certain critics called him an abstract artist. A friend of Kandinsky's, linked with the Expressionist review *Der Sturm* in Berlin, 1913, Arp met Ernst in Cologne and came to Paris after the War. It was in 1915 that he met Sophie Taeuber, whom he would marry in 1922. Entangled in the uprising at the Cabaret Voltaire, he delved into a Dadaist form of spontaneity, inventing the shapes that would define his work throughout his life. With a pure, refined style, he presented works that were always linked to something lifelike.

Breton's notes on Man Ray, Victor Brauner, Oscar Dominguez, Salvador Dali, Wolfgang Paalen, Frida Kahlo, Diego Rivera, Wilfredo Lam, Maria Toyen, etc. (which were often prefaces for exhibitions) only referred to their works sometime after 1934. We will come back to this. Painters contributed greatly to the development of Surrealism in the world, for the very simple reason that painting goes beyond language barriers.

The same could be said about photography, having already been in the limelight with the Dadaists' photomontages. Let us mention two famous Surrealist photos of members of the group which appeared in *La Revolution surréaliste*. In N° 1, the face of Germaine, who had just assassinated a militant royalist; and in N° 12, there is a female nude by Magritte with the inscription: "Je ne vois pas la femme nue cachée dans la forêt" (I don't see the nude woman hidden in the forest). All the Surrealists closed their eyes in perfect contentment...

Hans Arp

Dancer,

1925, oil on cut-out wood glued on woods, centre Pompidou-MNAM-CCI, Paris.

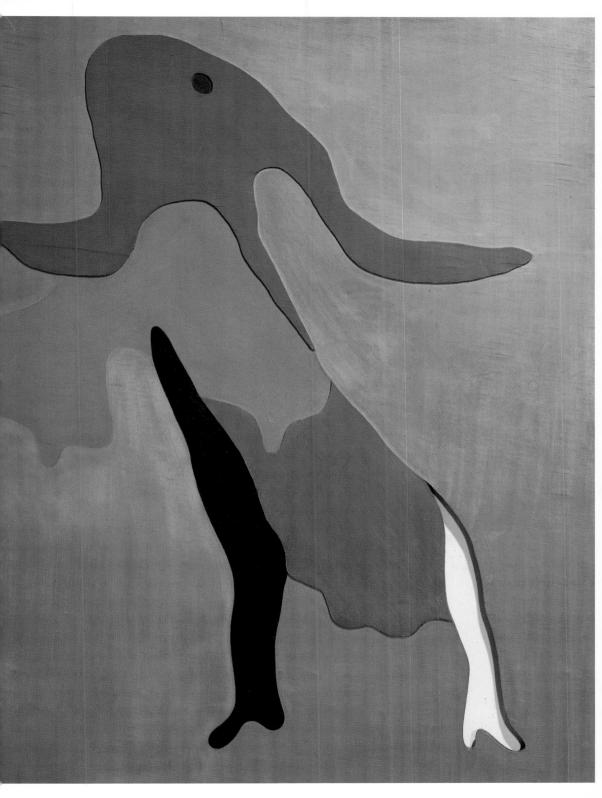

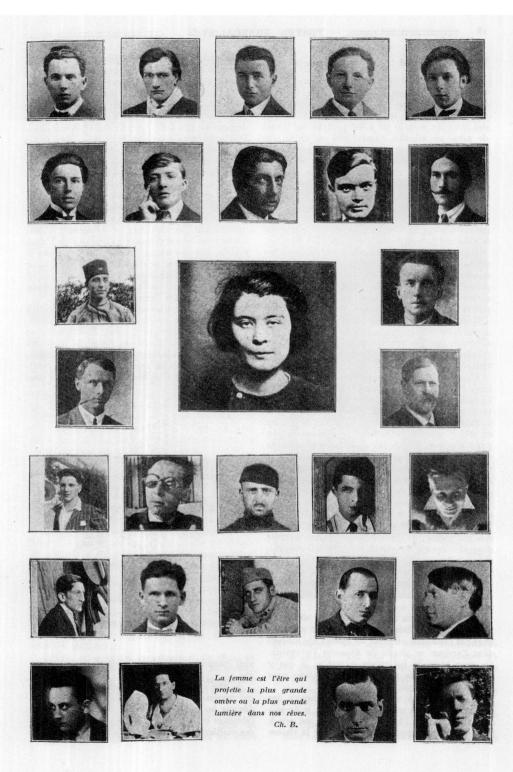

The Surrealists around Germaine Berton Illustration published in La Révolution surréaliste n°1, Ist December 1924.

There were two tendencies emerging in Surrealist photography:

1/ The *insolite* or outrageous on the street or in everyday life. Bellmer's nudes bordering on the indecent (1946) (cf. Catalogue: *Explosante fixe*, *photographie surréaliste*, p. 101), numerous portraits, unsettling sometimes in the case of Man Ray.

2/ Experimentation with direct work on the film as matter, having nothing to do with the lens of the camera. This led to numerous technical inventions including *solarisation*, (Man Ray) and *photo-relief* (The *Fossiles* [Fossils], by Raoul Ubac)...

There were a considerable number of Surrealist photographers in the world even if we only refer to an article by Édouard Jaguer in the *Dictionnaire général du surréalisme et de ses environs* (General Dictionary of Surrealism and its Surroundings, P.U.F., 1982). Its abundant documentation was read the world over. As for cinema, it was the contrary – the Surrealists were spectators more than creators. Darkened movie theaters were sanctuaries of the outrageous for wandering city dwellers. They went to working-class

movie houses where Feuillade and the first Charlie Chaplin films were shown. They were particularly fond of Les Mystères de New York and Les Vampires. Of course they applauded Sergeï Eisensteins's Potemkin, and their taste even evolved to the point of enjoying Alain Renais's Marienbad and Les Abysses by Nico Papatakis. For them, Murnau's expressionism (Nosferatu, le vampire), was the nightmare of sinister Surrealism. In fact, they were totally enamored with actresses such as Marlène Dietrich, Louise Brooks and later, Ava Gardner. In L'Amour fou Breton spoke of the film Peter Ibbetson, where every night in his dreams, the hero finds the same woman. Anicet and Le Paysan de Paris by Aragon, Poisson soluble (Soluble Fish) by Breton, La Liberté ou l'amour (Liberty or Love) by Desnos – all contain allusions to cinema.

The Surrealists' film creativity? But all cinema, as Ado Kyrou would write, "is of Surrealist essence..." And yet there were two films that created an uproar because of their extreme Surrealism, *Un chien andalou* (An Andalusian Dog) and *L'Âge d'or* (The Golden Age) by Salvador Dali and Luis Buñuel. In the first, it is impossible to explain the plot, but certain images remain, such as a razor blade cutting an eye, or the palm of

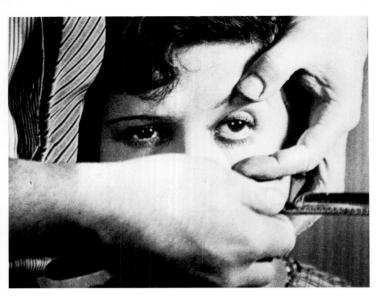

Scene from *Un chien andalou* by **Luis Buñuel**, 1929.

a hand teeming with ants... After the scandal over *chien andalou*, Buñuel began *L'Âge d'or*, financed by Charles and Marie-Laure de Noailles. The film came out in 1931. A kind of a dream, which first of all should make you dream, the film defies all logic, even symbolic. It sets an example of an absolute and gratuitous freedom of the imagination. Presented in Paris at Studio 28 in 1930, it greatly annoyed the Croix de Feu (extreme right-wing political movement). The locale was trashed and paintings by Miró, Ernst, Dali, shown in the lobby, were slashed. The film was banned for disturbing the peace, and would only be rehabilitated (by a *visa de sortie*) in 1981! (It was recently shown, with sound, on Arte, the Franco-German television channel).

Far from any political involvement, but violently anti-Christian, these films were an affirmation of Surrealism in its fundamental purity. The *Second Manifeste du surréalisme* would do as much in terms of pure doctrine.

Man Ray and René Magritte

I don't See the [Woman] Hidden in the forest,
Illustration by René Magritte and
photographed by Man Ray,
Published in La Révolution surréaliste
n° 12, December 1929.
From top left: Alexandre, Aragon, Breton,
Buňuel, Caupenne, Éluard, Fourrier, Magritte,
Valentin, Thirion, Tanguy, Sadoul, Nouqué,
Coemans, Ernst and Dali,
bibliothèque littéraire Jacques Doucet, Paris.

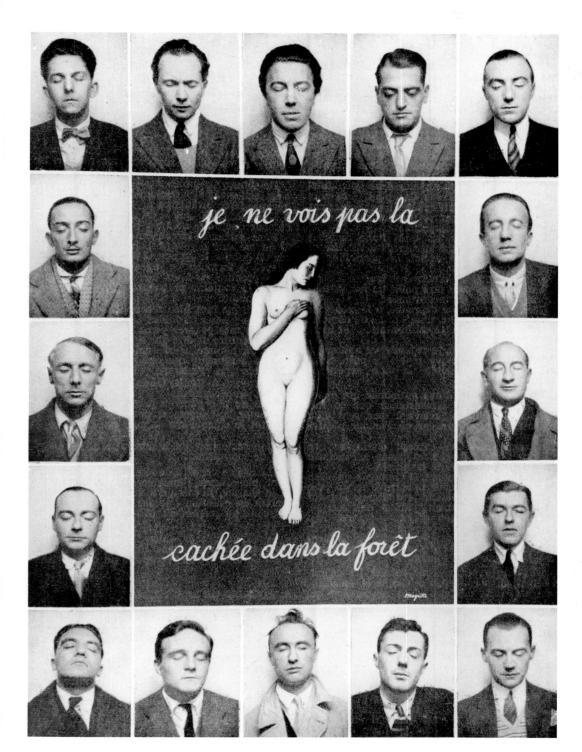

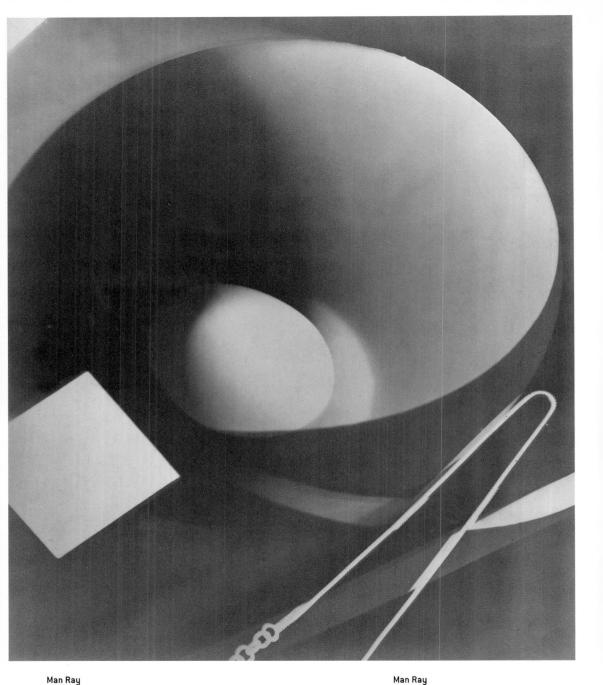

Delicious Fields 1st rayogram,
1922, gelatin silver print,
centre Pompidou-MNAM-CCI, Paris.

Jacqueline Goddard as a Nun,
Solarisation about 1934, gelatin silver print,
centre Pompidou-MNAM-CCI, Paris.

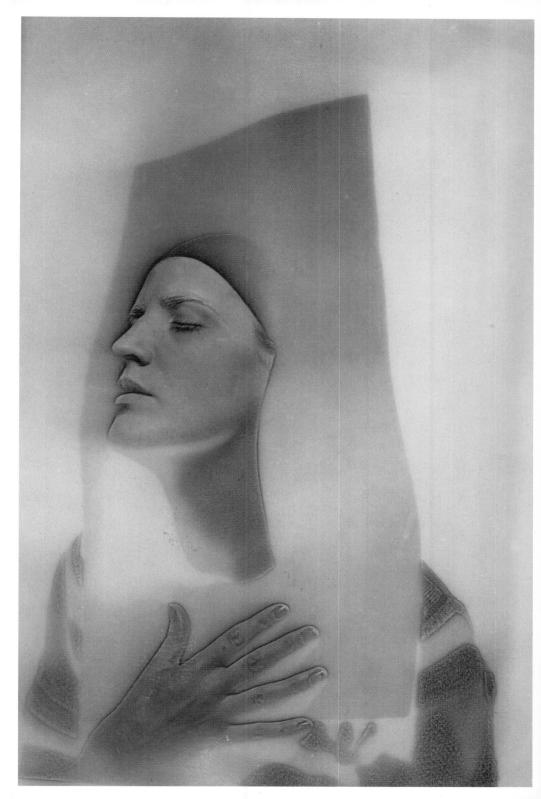

EXPANSION

The creation of SASDLR,

the title of which is already a political statement, could be misleading. In fact after the upheaval of the *Second Manifesto*, Surrealism returned to one of its sources, mental pathology. "Dream states" and "automatism" had not really shed any light on the real nature of creative inspiration.

Tentalathologis

In the second issue of this magazine, we find a review of Freud's book on *Le Mot de l'esprit dans ses rapports avec l'inconscient*, one of Breton's important works, "Mental Health in the Light of Surrealism" where the author attacks the psychiatrists' "misuse of power" and establishes what would later be called, antipsychiatry. Two major events marked this return to original sources:

- 1. The publication of Breton and Éluard's *L'Immaculée Conception* (Immaculate Conception), late in 1930, a masterpiece of Surrealistic research, going far beyond esthetic and political concerns.
- 2. The development of "Salvador Dali's paranoid-criticism."

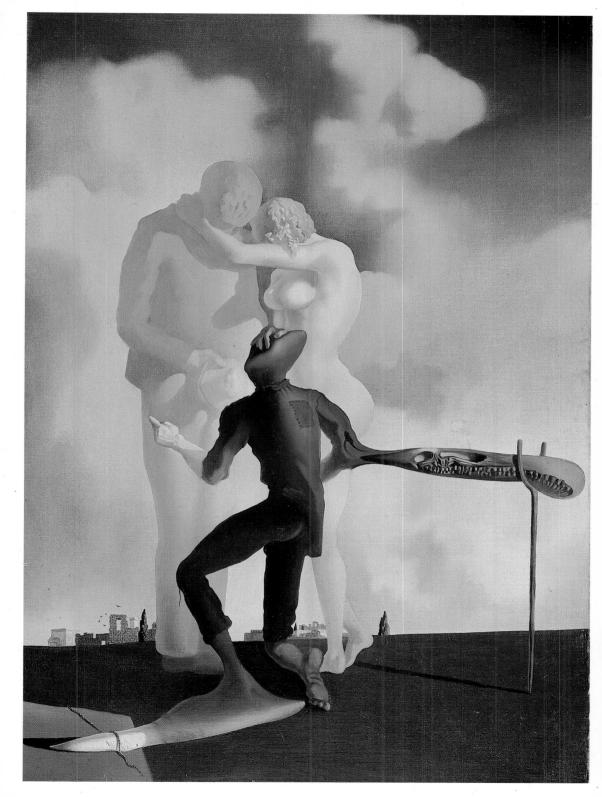

Published by Les Editions surréalistes, L'Immaculée Conception is an account of an experiment where the authors plunged into their own unconscious through "forms of possession": mental debility, manic behavior, general paralysis, interpretive delirium and precocious dementia. These "simulations" preceded by an allusion to the immaculate conception of the Virgin Mary, lead to a resurgence of "anti-religion" and talk of interuterine life (under the influence of Rank), of birth, of life and death - followed by a prolongation, where the concept of "mediations" intervenes, for example, force-of-habit, surprise, and love. The end of the book is a collection of aphorisms, where one can see, according to Hegel's dialectic, the synthesis of the two preceding movements. Thesis: a plunge into psychic obscurity; antithesis: the negation of obscurity in favor of reflection; synthesis: poetry seen as an ethic of clairvoyance. This is the moralist's style, imposing maxims like the book's last two lines:

Previous page:
Salvador Dali
Meditation on a harp,
About 1932-1934, oil on canvas,
Former André Durst Collection,
Morse Charitable Trust,
on loan Salvador Dali Museum,
St-Petersburg.

Salvador Dali

The Enigma of William Tell, 1933, oil on canvas, Moderna Museet, Stockholm.

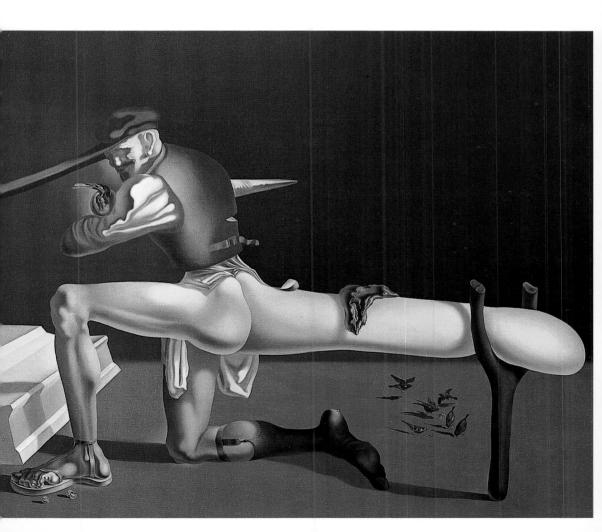

Frappe à la porte, crie : Entrez, et n'entre pas. Tu n'as rien à faire avant de mourir. Knock on the door, scream: Enter, and don't come in. You have nothing to do before dying.

Take the beginning of this simulation, which refers to the most visionary syndrome of all: Essai de simulation de la paralysie générale (Attempt at Simulating General Paralysis).

Ma grande adorée belle comme tout sur la terre et dans les plus belles étoiles de la terre que j'adore ma grande femme adorée par toutes les puissances des étoiles belle avec la beauté des milliards de reines qui parent la terre l'adoration que j'ai pour ta beauté me met à genoux pour te supplier de penser à moi je me mets à tes genoux j'adore ta beauté pense à moi toi ma beauté adorable ma grande beauté que j'adore je roule les diamants dans la mousse plus haute que les forêts dont tes cheveux les plus hauts pensent à moi – ne m'oublie pas ma petite femme sur mes genoux à l'occasion du coin du feu sur la sable en émeraude – regardetoi dans ma main qui me sert à me baser sur tout au monde pour que tu me reconnaisses pour ce

que je suis ma femme brune-blonde ma belle et ma bête pense à moi dans les paradis la tête dans mes mains.

My cherished one, beautiful as everything on earth and in the most beautiful stars on earth that I adore my great cherished woman adored by all the powers of the stars beautiful with the beauty of billions of gueens who adorn the earth the adoration that I feel for your beauty brings me down on my knees to beg you to think of me I put myself at your feet I adore your beauty think of me you my adorable beauty my great beauty whom I adore I rub diamonds in moss higher than the forests of which your highest hair thinks of me - don't forget me my little woman sometimes on my knees around the hearth on emerald sand - look at yourself in my hand that allows me to base my judgement on everything in the world so that you can recognize me for what I am my brunette-blond my beauty and my beast think of me in paradise my head in my hands.

We should add the end of the Essai de simulation du délire d'interprétation (Attempt at Simulating Interpretive Delirium), because we shall be very much dealing with paranoia in the years to come.

Following pages:

Salvador Dali

Metamorphosis of Narcissus,
1937, oil on canvas,
Tate Gallery, London.

Vous avouerez que vos lits-cages, et vos barreaux tordus, et vos planchers mordues, et vos muscades, et vos épouvantails à la dernière mode, et vos fils télégraphiques, et vos voyages en compartiment de pigeon, et le socle d'agneaux de vos statues de proie, et vos courses de haies faites au crépuscule de rouges-gorges qui s'envolent... Ne comptez plus sur moi pour vous faire oublier que vos fantômes ont la tournure des paradisiers. Au commencement était le chant. Tout le monde aux fenêtres! On ne voit plus, d'un bord à l'autre, que léda. Mes ailes tourbillonnantes sont les portes par lesquelles elle entre dans le cou du cygne, sur la grande place déserte qui est le cœur de l'oiseau du nuit.

You have to admit that your bed-cages, and your twisted prison bars, and your bitten floor boards, and your conjurer's balls, and your stylish fans and your telegraph wires, and your travels in pigeon cages, the pedestal of sheep for your statues of prey, and your obstacle courses of hedges made in the dusk of robins who fly away... Count no longer on me to make you forget that your ghosts resemble birds of paradise. In the beginning was song. To your windows everyone! From one end to the other all we can see is Leda.

My fluttering wings are the doors through which she enters into the neck of the swan, on the great deserted square that is the heart of the bird of the night.

In 1899, the well-known psychiatrist Kraepelin had defined interpretive delirium (paranoia) as "the insidious development, dependant on internal causes and following a constant evolution, of a system of long-lasting and impossible-to-eradicate delirium, that takes over without affecting one's clarity and order in thought, will and action." Most often it's question of the famous persecution complexes and delusions of grandeur that the patient doesn't want to let go of.

In his medical thesis *De la psychose paranoïaque dans ses rapports avec la personnalité* (Le François, publisher, 1932) Jacques Lacan studied the case of a young woman, Aimée, who became paranoid during her pregnancy. The woman believed both that the Prince of Wales was her lover and that a mob was persecuting her, wanting to harm her child. Finally, she stabbed an actress, and wound up in prison. Lacan published a detailed account of this case, and in an annex, published Aimée's storybook writings. He diagnosed a "curable self punishment psychosis" based on the single fact that once in prison, Aimée seemed freed

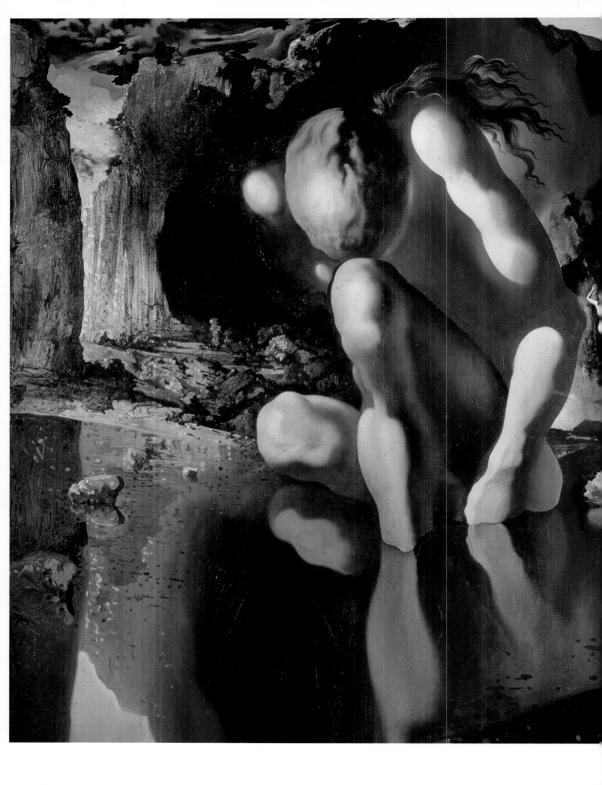

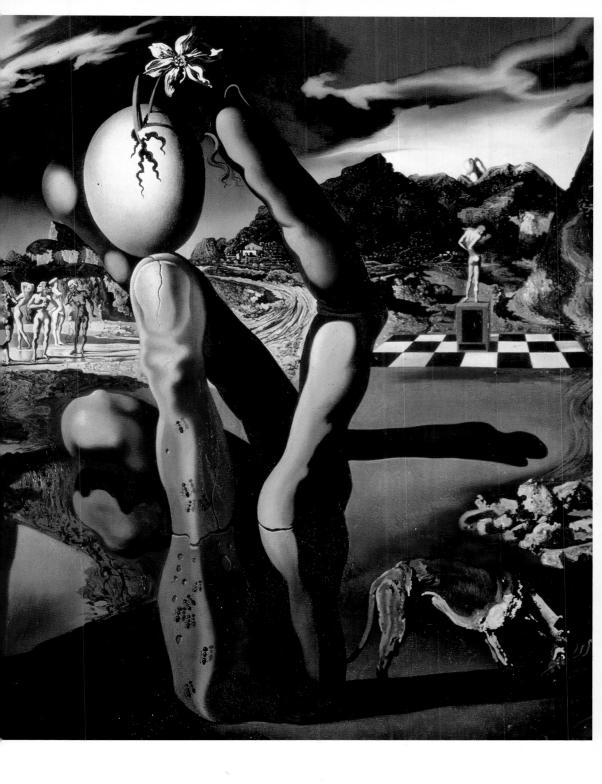

of her delirium – the real punishment erased the imaginery one... In fact Aimée returned to the mental hospital several months later, and Lacan's conclusions – based on this one case study – were nevertheless validated by the Surrealists who read this thesis with passion.

In 1932 the translation of an important work by Freud on paranoia appeared in Paris, in which Lacan was credited with "bringing a lateral contribution to Surrealism." Lacan published two articles in *Minotaure* in 1933: "Paranoid Forms of Experience" and "Paranoid Criminal Motivations" using the example of the Papin sisters. But it was Dali who first brought the notion of paranoia into the group, as well-noted by José Pierre (*Catalogue Dali*, centre Pompidou, vol. II, p.138).

Jacques Lacan spoke of paranoia after reading "L' âne pourri" by Dali in *SASDLR*, N°1, July 1930. It was in *La Femme visible* (The Visible Woman, Editions surréalistes, 1930) that the term "paranoia-criticism" appeared. This method is an "first class instrument" Breton wrote. We know where this comes from, in the case of Dali, this idea of integrating paranoia into the artist's creative, and thus critical, activity. He recounts

in his *Vie secrète* that as early as 1927 in Cadaquès, he had as neighbor a women of the fishermen, Lydia; who believed that Eugenio d'Ors was writing about her in his books and sending her love letters. This interpretive delirium particularly struck Dali, who was constantly terrorizing himself with the dead bodies of hedgehogs, grasshoppers and ants — therein lies the "fusion of reality and the imaginary" the very basis of Surrealism. The title of the painting *Le miel est plus doux que le sang* (Honey is Sweeter than Blood) is simply Lydia's wording.

In his book, *La Conquête de l'irrationnel* (Conquering the Irrational, 1935), Dali returned to the exposé of his method underlining its active nature. Dali's fantasizing would develop throughout his life, upon the theme of the lost paradise of the prenatal world. Nothing, regarding his creative activity, really permits us to divide Dali's life into two parts: a first Surrealist part lasting until 1939, then a betrayal of Surrealism with "Avida Dollars". His public eccentricities never interfered with his solitary concentration at Port-Lligat (Catalonia), as his obsession with dollars and Gala's avarice didn't prove that he was capable of managing a fortune...

For Dali, the inter-uterine paradise is "soft, immobile, warm, symmetrical, duplicitous and sticky." Throughout his life his painting would respond to this vertical inspiration, oriented toward the depths, (like Baudelaire in "La Charogne") which counters Breton's "ascendant". Reproduced here are some examples of his major works. Later, his obsession with viscosity would be combined with a fear of explosions, due to the anxiety surrounding the atomic bomb.

In fact, Dali was not paranoid. Whereas a patient obstinately believes in his delusions, Dali played, and never stopped playing with his dreams, attempting to bring them into his painting. In his *Vie Secrète* he wrote: "At dawn I woke up, and without washing or dressing, I would sit in front of the easel placed in my bedroom, opposite my bed. The first image of the morning was my canvas, which would also be the last thing I saw before going to bed. I tried to go to sleep staring at it in order to keep the drawing during my sleep, and sometimes in the middle of the night I would rise to look at it for a moment in the moonlight. Or, between two naps, I turned on the electricity and contemplated this work that never left me. All day, sitting in from of my easel,

I stared at my canvas like a medium trying to bring elements out of my own imagination. When the images were precisely placed in the painting, I painted them immediately. But sometimes I would have to wait for hours, passive, the paintbrush immobile in my hand, before seeing anything suddenly appearing." (p. 169). This procedure is the product of a highly nervous individual whose passion for perfection, capricious narcissism and "divergent" intelligence made for dilettante effervescence. The painter's ultimate goal was simply to paint his "inner model" in solitude. This desire can be seen in the surprising pages recounting the "cut-off hand" (horrible nightmare for a painter) in La Vie secrète de Salvador Dali (The Secret Life of Salvador Dali). In my opinion the Métamorphose de Narcisse (Narcissus's Metaporphosis, 1936) is the painting that resumes all Dali - of which Dali would write in Oui, "[This is] the first painting entirely produced by the strict application of the critical-paranoiac method." In the middle of a nocturnal orgy we see the reflection of Narcissus's body multiplying in the water, while a giant wrinkled hand holds out a narcissus blossom, in a sign of fragile hope... We will return to Dali later.

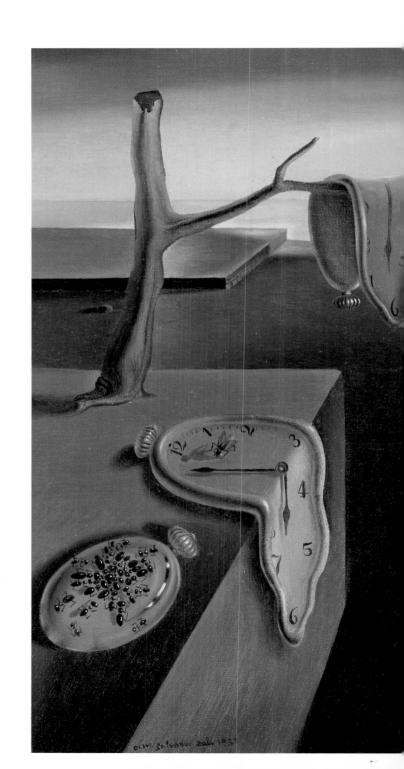

Salvador Dali

Persistence of memory, 1931, oil on canvas, The Museum of Modern Art, New York.

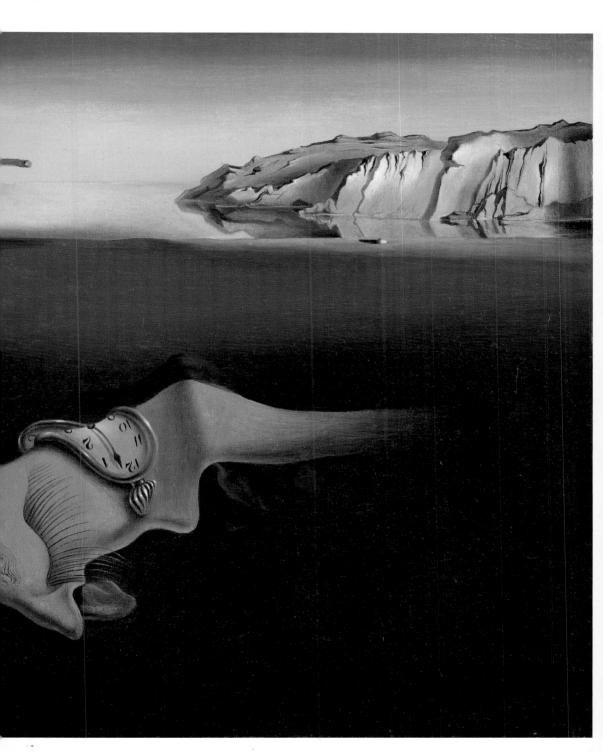

" die gole ge

Paranoia-criticism would be a source of stimulation in the creation of dream objects. Freud's "transitional objects" heavily sexual – finding quite out-of-the ordinary objects in the flea market, driftwood, discolored by salt, found on the beach, the use of everyday objects in some humorous or absurd manner, the call for objects from the far end of the earth... this world, infinitely rich, was periodically revisited by the Surrealists.

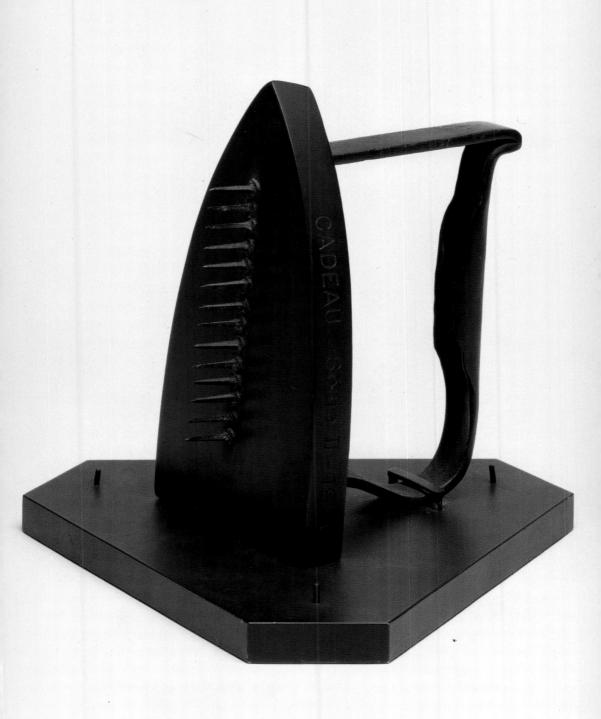

Previous page:

Man Ray

Gift,

1921, gelatin silver print,
centre Pompidou-MNAM-CCI, Paris.

fantasy touching on obsessional subjects such as "la broyeuse de chocolat" [the chocolate grinder]]

 and an article by Roger Caillois on the "Specification of Poetry", where we read, "It is clear that the utility of

an object never completely justifies its form, in other

We have already mentioned Duchamp's readymades and the Cadeau (gift) by Man Ray. Dada had already toyed with the Tête mécanique (Mechanical Head) by Raoul Haussmann, and Kurt Schwitters had already composed his Mertz objects out of garbage. But it was starting in 1930, and especially in 1935, that the first truly Surrealist objects would appear. And this, all over the world. To such an extent that one could consider this "chosiste" ("thingist") activity (the word is Bachelard's) like a determining factor in the cosmopolitan character of the great International Exhibitions of Surrealism (London in 1936, Paris in 1938 etc.).

words, the object always goes beyond the instrument. In this manner, it would be possible to discover in every object an irrational residue, determined among other things by the inventor's or the technician's unconscious representations." It would be in this residue (which is undoubtedly a plus) that can be found the essential for a Surrealist.

A few pages later Dali mentions "anamorphic psychoatmospheric objects" (anamorphosis is the deformation of an image, or of the form of an object, through

Let us first say a word about the Surrealist texts relative to the question. They tell us specifically what makes an object Surrealist. In 1931 (N° 3 of LSASDLR), Salvador Dali proposes a "general catalogue of Surrealist objects" where one can find L'Heure des traces by Alberto Giacometti prominently placed. This was one of the first fully Surrealist objects. In the same issue we find Breton's text on L'objet fantôme, (excerpt from his book, Les Vases communicants).

a rew pages later Dall mentions anamorphic psychoatmospheric objects" (anamorphosis is the deformation of an image, or of the form of an object, through the use of an angle of vision taken from the edge of the perspective — very popular in the Renaissance). And in N° 6, a long account of experiments involving "irrational knowledge" of objects such as a cristal ball, indeed, involving the "possibilities of the beautification of a city." In answer to the question: "How can one improve upon the Panthéon?", Tzara replied: "Split it down the middle and separate the two halves by 50 cm".

In N° 5 (May 1933) Marcel Duchamp's text which was supposed to explain *La mariée mise à nu par ses célibataires, même* (this *Grand Verre* contains a graphic

Alberto Giacometti

The Invisible Object, 1934-1935, bronze, Maeght Foundation, Saint-Paul-de-Vence.

Marcel Duchamp

The Bride Sripped Bare by the Bachelors, even, 1913–1914, painting on glass, Philadelphia Museum of Art, Philadelphia.

Meret Oppenheim

The Lunch in Fur,
1936, Fur-covered Tea Cup,
Saucer and Spoon,
The Museum of Modern Art, New York.

e the Divine. Let us confirm that the "new style of mysticism" that Aragon called for in a work dating from 1925, remains anchored in earthly life

Alberto Giacometti

The Palace at Four in the Morning, 1932-1333, construction in wood, glass, metal, string. The Museum of Modern Art, New York.

In Le Surréalisme et la Peinture (1965 edition) we find Breton's texts "Crise de l'objet" where he calls upon modern science to validate Surrealism, and "Du poème-objet", where it is simply a question of replacing words by tiny things stuck together. Surrealism wouldn't be satisfied with detecting the "residue" that Caillois describes, it creates it like a surplus of the marvelous, it makes a poem out of an object, by displacing and modifying it. Giacometti explains that he dreams of an object in minute detail long before he actually creates it. In this manner Le Palais à quatre heures du matin (The Palace at Four in the Morning, 1932) is simultaneously the fulfillment of a dream and what Freud calls a "dream gear shift" he inspires us. L'Objet invisible (The Invisible Object – the title Breton gave to this sort of statue, which seems to be holding something missing between its hands) is Giacometti's last Surrealist object; he then concentrated on his sculpture. Beginning in 1935, he repudiated his Surrealist period; one wonders why...

It was in 1936, at the home of Charles Ratton, that the first major exhibition of Surrealist objects took place, to which the *Cahiers d'art* devoted a special issue

which furnishes the nomenclature of the Surrealist objects exhibited: objets naturels (natural objects including a stuffed ant-eater), naturels interprétés (interpreted natural objects), naturels incorporés (incorporated natural objects), objets perturbés (perturbed objects, works of glass melted by volcanic lava). objets trouvés (found objects), objets trouvés interprétés (interpreted found objects), objets amérindiens et océaniens (American Indian and Oceanic objects), plus the Porte-bouteilles (readymade) by Duchamp, des objets mathématiques (mathematical objects, pedagogical) and finally objets surréalistes, created from scratch: Trousse de naufragé (Instrument Case for the Drowned) by Arp, Veston aphrodisiague (Aphrodisiac Jacket) by Dali Arrivée de la Belle Époque (Arrival of the Belle Epoque) by Dominguez, the objects by Giacometti, Hommage à Paganini by Maurice Henri (fantastic!), a version of Cadeau by Man Ray (sadistic), poem-objects by Breton and all his friends, and finally the most famous of all, Le Déjeuner en fourrure (The Lunch in Fur) by Meret Oppenheim (who would later invent the disturbing Chaussures Siamoises [Siamese Shoes], sewn together at the tip].

Oscar Dominguez

Nostalgia for Space,
1939, oil on canvas,
The Museum of Modern Art, New York.

Denise Bellon

Never.

Oscar Dominguez, at the Exposition internationale du surréalisme, galerie des Beaux-Arts, Paris, 1938, galerie Claude Oterelo, Paris.

Denise Bellon

Le Taxi pluvieux, by Salvador Dali at the Exposition internationale du surréalisme, galerie des Beaux-Arts, Paris, 1938, galerie Claude Oterelo, Paris.

Many of these objects were exhibited at L'Exposition internationale du surréalisme in 1938 (Paris). Instead of exhibiting the objects in a traditional manner with works juxtaposed, the galerie des Beaux-Arts itself was treated like a kind of architectural object fitted-out for the occasion. At the entrance one was greeted by Dali's Taxi pluvieux (Rainy Taxi), in which a beautiful blond woman (wax) is assaulted by a squad of live snails. Then comes the Rue surréaliste lined with mannequins, each pretty woman had been dressed by an artist according to his most intimates fantasies (Léo Malet's goldfish in a bowl placed in a mannequin's belly had been judged too risqué...). Le Déjeuner en fourrure was shown in the main room, in which the ceiling had been decorated with coal sacks (by Duchamp)

and everywhere, hands, especially in Dominguez's composition, Jamais (Never), where the bell of a gramophone swallowed up a woman's legs while the arm of the record-player had been replaced by a hand... Following the exhibition's catalogue came out a Dictionnaire abrégé du surréalisme which consisted of "discoveries" from the cadavres exquis (Exquisite Corpses). We will later encounter other major exhibitions where the poetic dream-state will know how to impose Surrealist sensitivity on the general public. For the moment we are in 1938 and André Breton's group is still in the midst of their political crisis. Let's back up a bit.

Rue surréaliste at the Exposition internationale du surréalisme, galerie des Beaux-Arts, Paris, 1938.

d revolt, in order to reach the supernatural level of poetry in all areas of life. We will now see how historical circumstances would modify its actions

political QII oblic 171

A few pages after Dali's "L'âne pourri" in N° 1 of SASDLR a letter by Mayakovski was published at the time of his suicide, where the line "Love's raft was broken to pieces running up against everyday life" serves as the title of a long article by Breton about the relationship between revolutionary fervor and love. Women supposedly "detest everything that isn't done for the sake of their beauty" for Mayakovski killed himself both out of despair in love and out of deception in politics. The problem being that in spite of Engels's reservations, a person's right to love, like death, is absolute. The ambiguity of Breton's position is that of a diplomat attempting to maintain an equal balance between the two options offered by Surrealism at that time - commitment to the Third International and Communist Ideal, and individual artistic creativity. These two ideals which were to become distorted from a historical perspective, would be fundamentally, indissolubly linked.

Previous page: Wilhelm Freddie

Sex-Paralysappeal, 1936, sculpture, Moderna Museet, Stockholm.

Denise Bellon

Salvador Dali at the Exposition internationale du surréalisme, galerie des Beaux-Arts, Paris, 1938, galerie Claude Oterelo, Paris.

Denise Bellon

The Street of Blood transfusion, at the Exposition internationale du surréalisme, galerie des Beaux-Arts, Paris, 1938, galerie Claude Oterelo, Paris.

However, while Breton maintained this balancing act, Aragon and Sadoul gave in and left for Kharkov, USSR, for the Second Congress of Revolutionary Writers and Intellectuals. In SASDLR N° 3, Aragon, back from Kharkov, attempts to put things into place theoretically. His article "Le surréalisme et le devenir révolutionnaire" (Surrealism and Revolutionary Evolution) states that in the realm of action, the final word must come from the 3rd International Communist Committee. Noting that the bourgeoisie - who had just condemned Sadoul to three months of prison for having sent an insulting letter one drunken evening, to majors at Saint-Cyr (Caupenne, guilty of complicity, formally apologized and was let off] - subtly undermines and handicaps the Surrealists, forcing them into the arms of high society snobbish patrons, managing to distance them from intellectuals sympathetic to the USSR. And yet, Aragon maintained that he went to the Congress out of pure pleasure...

In fact, once there he gave in to everything that was asked of him. He went as far as calling psychoanalsis "idealist" (horrors!) and signing a petition against Trotsky. In order to justify his adherence to Stalinist

Communism, he wrote a violent poem, "Front Rouge" [The Red Front] in which one can read some fairly wretched "party line" insults, such as, "I fire upon the trained bear of social democracy..." Aragon is then accused of inciting murder and the Surrealists, with Breton leading some 300 intellectuals, sign a petition in defense of Aragon... and of poetry.

One can see the difficulty: If poetry does not assume the consequences of its existence, and in the name of the poet's unconscious drives, relieves him of all notion of responsibility, where is its place in a revolutionary context? One accepts one's responsibilities or one does not. Breton's position is ambiguous. He did not like this "poem of circumstance". And Aragon had been placed in a difficult position with this manifestation of support. If he approved, or so it seemed - at least until the day that a tiny line in L'Humanité revealed that Aragon "entirely disapproved" of the contents of the document written in his defense. A few jolted Surrealists trying to maintain their faith in the French Communist Party, as far as action's concerned, -but what action? - couldn't hide the evidence: Aragon had left.

Louis Aragon at the time of the Spanish War. (On the wall portrait of Mayakovski).

Ne visitez pas l'Exposition Coloniale

A la veille du 1^{et} Mai 1931 et à l'avant-veille de l'inauguration de l'Exposition Coloniale, l'étudiant indo-chinois Tao est enlevé par la police française. Chiappe, pour l'atteindre, utilise le faux et la lettre anonyme. On apprend, au bout du temps nécessaire à parer à toute agitation, que cette arrestation, donnée pour préventive, n'est que le prélude d'un refoulement sur l'Indo-Chine.* Le crime de Tao? Etre membre du Parti Communiste, lequel n'est aucunement un parti illégal en France, et s'être permis jadis de manifester devant l'Elysée contre l'exécution de quarante Annamites.

L'opinion mondiale s'est émue en vain du sort des deux condamnés à mort Sacco et Vanzetti. Tao, livré à l'arbitraire de la justice militaire et de la justice des mandarins, nous n'avons plus aucune garantie pour sa vie. Ce joli lever de rideau était bien celui qu'il fallait, en 1931, à l'Exposition de Vincennes.

L'idée du brigandage colonial (le mot était brillant et à peine assez fort), cette idée, qui date du XIXe siècle, est de celles qui n'ont pas fait leur chemin. On s'est servi de l'argent qu'on avait en trop pour envoyer en Afrique, en Asie, des navires, des pelles, des pioches, grâce auxquels il y a enfin, là-bas, de quoi travailler pour un salaire et cet argent, on le représente volontiers comme un don fait aux indigènes. Il est donc naturel, prétend-t-on, que le travail de ces millions de nouveaux esclaves nous ait donné les monceaux d'or qui sont en réserve dans les caves de la Banque de France. Mais que le travail forcé — ou libre — préside à cet échange monstrueux, que des hommes dont les mœurs, ce que nous essayons d'en apprendre à travers des témoignages rarement désintéressés, des hommes qu'il est permis de tenir pour moins pervertis que nous et c'est peu dire, peut-être pour éclairés comme nous ne le sommes plus sur les fins véritables de l'espèce humaine, du savoir de l'amour et du bonheur humains, que ces hommes dont nous distingue ne serait-ce que notre qualité de blancs, nous qui disons hommes de couleur, nous hommes sans couleur, aient été tenus, par la seule puissance de la métallurgie européenne, en 1914, de se faire crever la peau pour un très bas monument funéraire collectif — c'était d'ailleurs, si nous

^{*} Nous avons cru devoir refuser, pour ce manifeste, les signatures de nos camarades étrangers.

"Don't Visit the Colonial Exhibition."
1931, Surrealist tract.

We cannot ignore that this political-emotional abduction was of a passionate nature that insured Aragon's loyalty to Surrealism at the very moment of his departure. In fact, it was in Kharkov that Aragon found again Elsa Triolet (they had first met in Paris in 1928), sister of the Lili to whom Mayakovski wrote, in his last letter, "Lili, love me." Elsa, who would only be a "sympathizer" with Communism seems to have converted Aragon rather quickly not only to the Party, but also to the lyricism of love. She became his idol, and during years Aragon would "sing" his love in poems such as Les Yeux d'Elsa (The Eyes of Elsa). Was Aragon won over to Stalin out of the love of Elsa? So, is there really nothing pure, even among the pure of heart? Aragon, who at the time of the "Naville affair" consid-

Aragon, who at the time of the "Naville affair" considered political action "dishonoring" became a member of the French Communist Party in 1936 after several trips to the USSR. Adopting Zhdanov's theory of

"Socialist Realism" he published his poem "Hourra l'Oural" (Hurrah the Ural!) in 1934. Breton for his part, was drawing nearer to Trotsky, founder of the Red Army and then "glorified" with the "prestige" of having been sent into exile. The five Surrealists who were members of the French Communist Party were excluded in 1933, a dark year, the year of Hitler's ascension, the burning of the Reichstag and the founding of the Gestapo...

The Surrealists had participated in the counter-exhibition aimed at the 1931 Exhibition of the Colonies, (where Artaud had discovered Balinese theater). Not inclined to support Henri Barbusse and Romain Rolland in their pacifist undertakings, the Surrealists published their pamphlet *La mobilisation contre la guerre n'est pas la paix*, in 1933. One can read: "If you want peace, prepare for civil war." *SASDLR* N° 5, in May 1933, published a letter addressed to Breton by the philosopher Ferdinand Alquié, in which he rages against "the wind

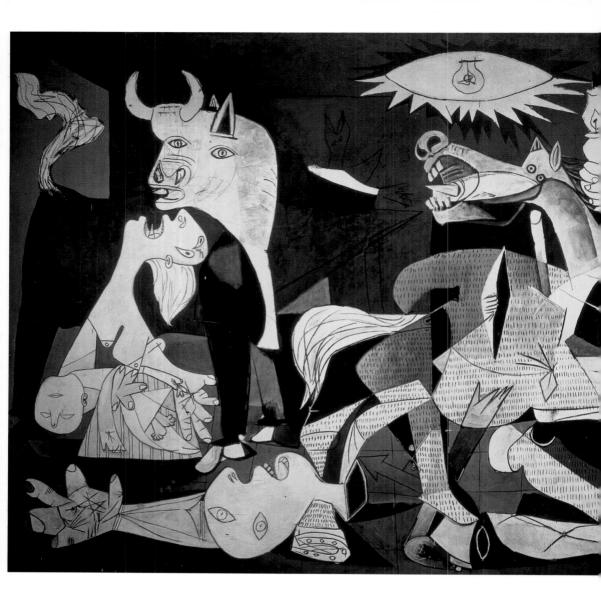

Pablo Picasso

Guernica,

1937, oil on canvas,

Centro de Arte Reina Sofia, Madrid.

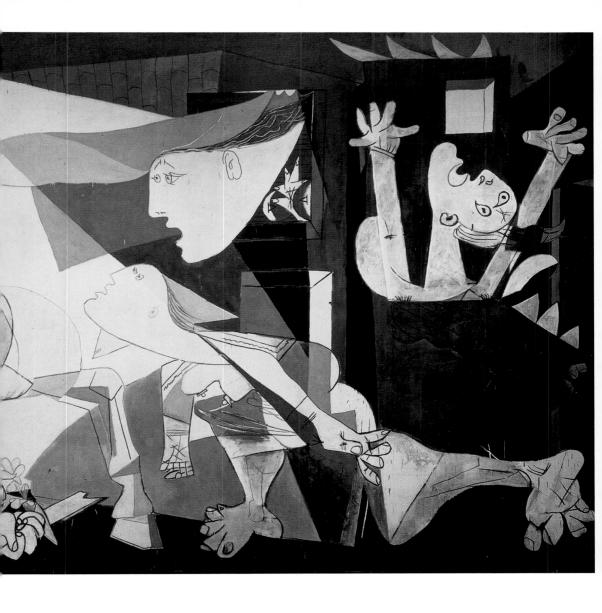

André Breton with Diego Rivera, Frida Kahlo, Trotsky in Mexico City, in 1938.

of 'idiotization'that is blowing from the USSR." The personality cult of Stalin, in fact, was paving the way for films that would appear completely ridiculous to the Surrealists... In the face of the movements of the extreme right in France, which would culminate on 6 February 1934, the Surrealists intoned slogans such as "War on war". After their text Appel à la lutte [Call to Fight, 10 February), they joined the "Comité de vigilance des intellectuels antifascistes" (Vigilant Committee of Antifascist Intellectuals) and signed their manifesto. Laval's pact with the USSR brought the French Communist Party closer to the government, and the Surrealists could only distance themselves from this line of national unity. At a pacifist meeting for the defense of culture, René Crevel would be the only Surrealist tolerated. But, he committed suicide. It was Éluard who would read a text by Breton (no longer allowed to take the floor since having slapped Ilya Ehrenburg). Breton objected to the "about-face" that allowed Communists to defend the idea of national identity. But all this fell on deaf ears and it was in vain that he attempted to distinguish living art from that of the conservatives

In an attempt to show that a disengagement with Stalin was not a disengagement with the revolution, Breton, who in 1932 had published Les Vases communicants (in which he shows that desire, in a waking state, leads to revolution and, in a dreaming state, to poetry) - wrote Position politique du surréalisme (Political Position of Surrealism), where he announced the formation of the group Contre-Attaque (Counter-Attack), "the intellectual revolutionaries'union for struggle". Bataille would be the leader of this group. Their leftist position would leave them on the outskirts of the mass movements of 1936 and the Popular Front. Worried to see that in Europe revolutionary movements often turned into fascism, they proclaimed that the defense of revolution should be "aggressive". However a text in Contre-Attaque having indicated that they preferred "in all events and without being taken in, Hitler's anti-diplomatic brutality, less surely mortal for peace than the slobbery excitation of diplomats and politicians" the Surrealists withdrew their signatures, refusing to fight fascism with a "superfascism." The group was shaken by this contradiction, and disbanded on its own.

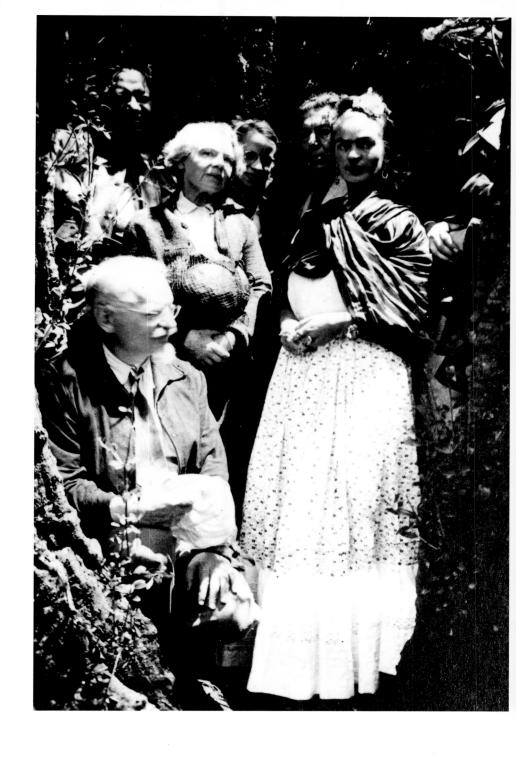

1937 was the year of the Universal Exhibition "Arts et Techniques" in Paris. For the first time one could see Picasso's large wall painting Guernica in the Spanish Republic's pavilion. The Spanish Civil War (and the non-intervention of France) lead to a hardening of the left. Péret, among others, joined the "Durutti Column" along with the anarchists. He would come back only in 1939. Artaud had left for Mexico in 1936. He discovered the Tarahumara Indians and their "dance of peyote" a hallucinogenic in which he recognized with exaltation the discovery of this own psyche. Returning to Europe in 1937, he suffered seizures on the ship that resulted in his confinement to a mental hospital upon arrival in Le Havre. This was the beginning of a long martyrdom in several psychiatric hospitals, ending with the Rodez Hospice in 1942. We will return later to Artaud, who lived out in his own skeletal body the experience that others only knew through simulation or out of curiosity.

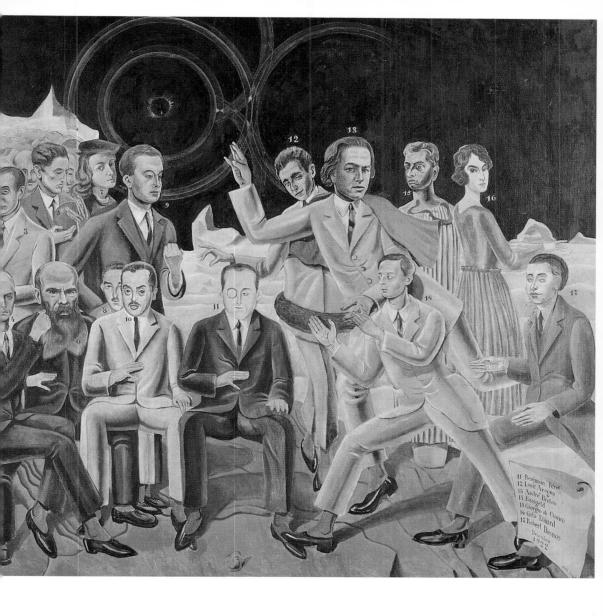

Max Ernst

At the rendez–vous of Friends, 1922, oil on canvas, Ludwig Museum, Köln. In 1938, the year of Munich, Breton went to Mexico where he met Leon Trotsky at the home of the painter Diego Rivera. He found to his pleasant surprise that they shared similar ideas about art. The artist participates in the future of permanent revolution if he is truly faithful to his inner voice. Breton then founded the Fédération internationale des artistes révolutionnaires indépendants (FIARI) and in the manifesto (another one) Pour un art révolutionnaire indépendant repeats that art should be beyond national identities. Back in France, he published the bulletin Clé: "Art no more has a national identity than do workers." (N°1) In the second and last number he presented a text by Trotsky. Dissention within the inner circle – Éluard, having moved closer to the French Communist Party, was excluded from the group - soon led to its breaking up.

When mobilization was announced, the contradiction between verbal jousting and real action was flagrant.

The Surrealists went to their assigned posts without hesitation. Jean-Louis Bédouin noted: "The refusal to serve in the military, which remains the rule in Surrealism, doesn't suit certain leaders of the movement, going as far as to the will to *de-serve*." (Vingt ans de surréalisme [Twenty Years of Surrealism] Denoël, 1961, p.31).

It is obvious that the political discords that shook the Surrealist group left their scars. The painters, especially, were never particularly interested in doctrine, and maintained a certain distance from the revolutionary fervor. The ambiance surrounding Breton was becoming insufferable. Ernst was fed up and wanted to leave the group. He recounts, "The opportunity was presented to me when a perfectly candid Benjamin Péret, acting as the chief's emissary, came to my illegal lodgings, 12 Rue Jacob, one day in December 1938, in order to inform me that for political reasons, each member of the Surrealist group was called upon

to 'sabotage Paul Éluard's poetry, using any and all means at their disposal.' Orders from the top. Refusal would mean exclusion." (*Max Ernst*, Gonthier Seghers III, p. 27-28). In fact Breton's intellectual authority wasn't the only cause for dissention within the group during this period of expansion. Individual notoriety took its toll. Robert Lebel wrote, "It was a fact that they ran up against a paradox – Surrealism attempted to stay out of the public eye, at the very moment that Surrealist painters were becoming famous."

SASDLR folded in 1933 and was immediately replaced by the review *Minotaure*. It is interesting to note that the word revolution was no longer found in the titles of Surrealist reviews, and would only reappear briefly in the ephemeral attempt with *Surréalisme révolutionnaire* in 1946. Implicitly for the moment, the motto in the thirties seemed to be: "Surrealists of the world, unite!"

St. centri centu Paris between broug

Surrealism's first expansion was paradoxically centripetal. We know that as of the beginning of the century numerous artists from every horizon came to Paris from all over. The phenomenon would continue between the two world wars. Dada and Surrealism brought notably Francis Picabia (Cuba and Paris), Hans Arp (Switzerland), Joan Miró and Salvador Dali (Catalonia), Maria Cerminova, called "Toyen" (Czechoslovakia), Roberto Matta (Chile), Hans Bellmer (Poland), Victor Brauner and Jacques Hérold (Rumania), Man Ray, Kay Sage, Joseph Cornell and William Copley (United States), Oscar Dominguez, Esteban Francès (Spain), Wilfredo Lam (Cuba), René Magritte, Paul Delvaux, Félix Labisse, Raoul Ubac (Belgium), Wolfgang Paalen (Austria), Kurt Seligmann (Switzerland), Max Walter Svanberg (Sweden), Abdul Kader El Janaby (Iraq), not to mention Picasso, De Chirico or Chagall. The Dane Wilhelm Freddie would be remarked for his anti-Nazi violence. His exhibition Surreal-Sex (Copenhagen, 1938) brought him death

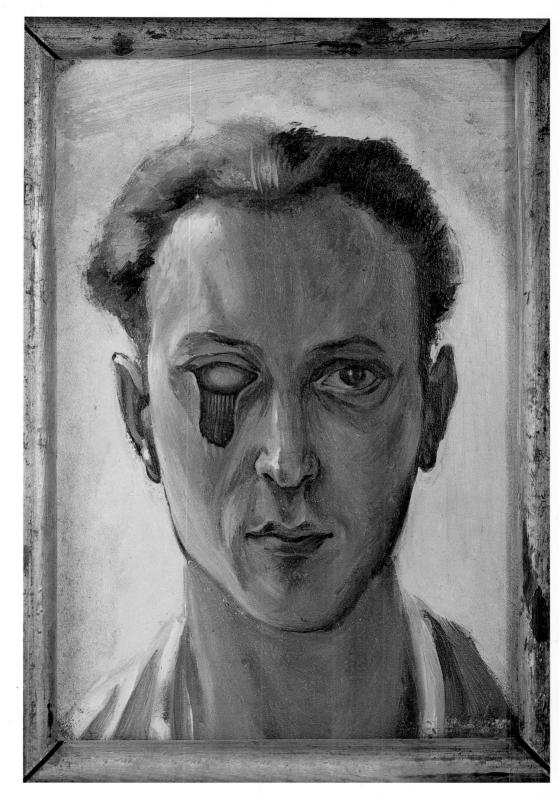

Previous page:

Victor Brauner

Selfportrait with Pitted Eye,
1931, oil on wood,
centre Pompidou-MNAM-CCI, Paris.

Joan Miró

Cover of Minotaure n° 7, June 1935.

threats. He sought refuge in Sweden, and would later live in France. All these artists came to Paris to find what Chagall called an "astounding light – freedom". The great international exhibitions, such as the one held in Paris in 1938, proved to the general public that the Surrealists were not only international, but also eminently cosmopolitan.

Later, in a completely opposite movement, Surrealism spread to other countries. Major exhibitions took place: starting with Hartford (U.S.) in 1931. And in New York in 1936, "Fantastic Art, Dada, Surrealism" was organized by Alfred Barr at the Museum of Modern Art in New York. Followed Zurich, Santa Cruz de Tenerife, and Tokyo in 1937, London 1936, Santiago del Chile, Mexico City (1940), etc. Surrealists books were translated: note in Minotaure N° 10 a double-page spread of photos, "Le Surréalisme Autour du Monde" (Surrealism Around the World). Other groups were forming, information circulated thanks to the Bulletin international du surréalisme, which was first published in Prague in 1935, N° 2 in Brussels and N° 3 in London in 1936. In 1934 Dali met with great personnel success in New York. This was the same year that the Czech chapter would form, becoming one of the most active, followed by England, Portugal and Japan (several reviews), Brazil... It was in Yugoslavia that Marco Ristic led the Serbian Surrealist group beginning in 1924. It is noteworthy that in spite of the 1932 repression, the Surrealists integrated Tito's government. The Czechs, who had warmly welcomed Breton and Éluard in 1938, would suffer several waves of repression; however, in the end they were the only people not to have given in to Stalin's reign of terror.

The political repression often led to exile for example the Iraqi Abdul Kader El Janaby, or the Egyptian Ramses Younnane (founder of the review *La Part du sable*, along with Georges Hénein). This phenomena however involuntary, led to the international diffusion of Surrealism.

This said, the new avant-garde review in France, *Minotaure*, founded by a Swiss, Albert Skira, was simultaneously cosmopolitan and very open to cultural diversity. From 1933 to 1939, the thirteen successive issues were luxuriously presented, with front pages created by great painters, (Picasso, Duchamp, Magritte, Ernst, Masson, among others). The review was not only a beautiful object, it was also meant to be "state of the art" with regard to what we now call

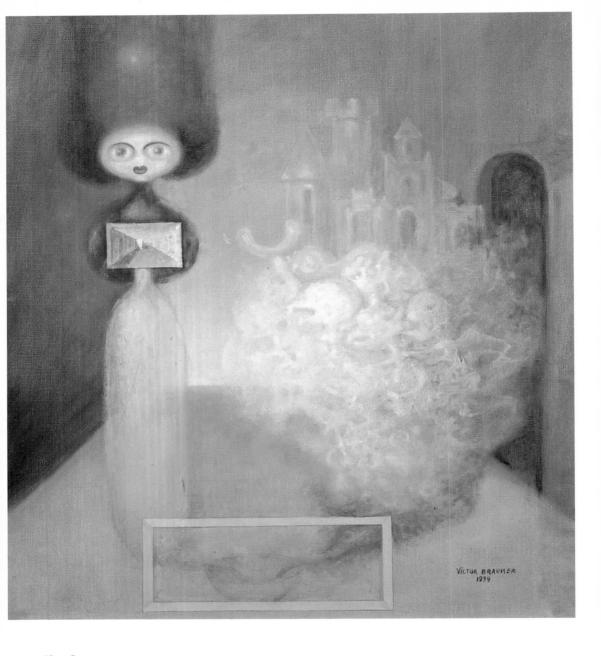

Victor Brauner

Chimera,

1939, oil on canvas,

Former Thyssen-Bornemisza Collection.

social studies, then represented by psychoanalysts or ethnologists. The science of art is integrated with general anthropology and the second issue of *Minotaure* was entirely dedicated to the Dakar-Djibouti mission. This expedition, led by Marcel Griaule, seconded by Michel Leiris, brought back objects ("stolen" maintained Leiris, in order to prove the cultural existence of the populations they encountered). These objects were left in what would become Le musée de l'Homme, in Paris in 1936.

With regard to psychoanalysis, we have quoted works by Lacan, and Breton attempts a self-analysis in his poem "La nuit du tournesol" (Night of the Sunflower – N° 7). This perspective is widened to include sexology, with Caillois ("La mante religieuse" N° 5) and Maurice Heine, a specialist on Sade, likewise for the study of the esoteric element in myths and rituals. In "LŒil du peintre" (N° 12-13) Dr. Mabille studies the strange phenomena of premonition. In the course

of a fight, Victor Brauner was struck and blinded in one eye by glass shards. Ubac maintains that he saw Brauner's right eye hanging on his cheek. Now Brauner had painted the *Autoportrait à l'Œil énucléé* (Selfportrait with Pitted Eye) in 1931. Mabille tries to explain this phenomena with psychoanalysis. It is impossible to really know, so the enigma is exacerbated.

Dali figures in *Minotaure* with several snappy articles: "Interprétation paranoïaque-critique de l'image obsédante *L'Angélus* de Millet" (Critically-Paranoiac Interpretation of the Obsessive Picture *The Angelus* by Millet), "De la beauté terrifiante et comestible de l'architecture Modern Style" (About the Terrifying and Edible Beauty of Modern Style Architecture, N° 3-4), "Le sex-appeal Spectral" (Ghostly Sex-appeal, N°5) and "Le surréalisme spectral de l'Éternel féminin préraphaélite" (The Ghostly Surrealism of the Eternal Feminine Pre-Raphaelite, N°8, 1936).

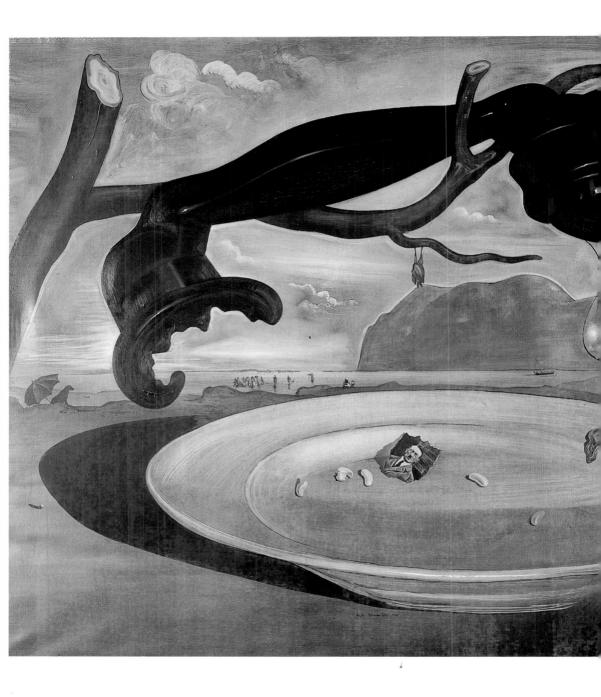

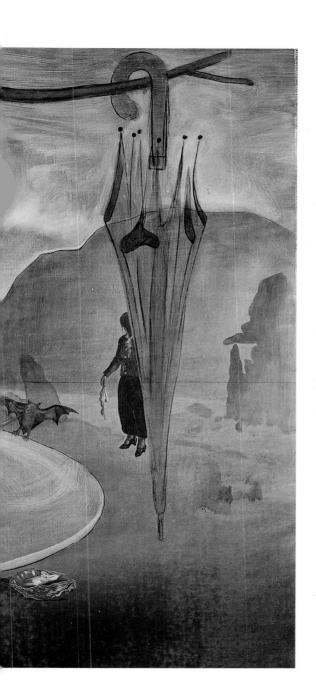

Salvador Dali

The Enigma of Hitler,
About 1939, oil on canvas,
Centro de Arte Reina Sofia, Madrid.

Victor Brauner

Needles of Ice, 1938, oil on canvas, Private Collection.

Breton presents several important texts: "Picasso dans son élément" (Picasso in His Element, illustrated by Brassaï), "Le message automatique" (The Automatic Message), "La beauté sera convulsive" (Beauty Will Be Convulsive, N°5), a text that will be used again in *L'Amour fou*, "Phare de la Mariée" (The Lighthouse of the Married Woman), where he attempts to understand Duchamp's *Grand Verre*, "Le merveilleux contre le mystère" (The Marvelous as Opposed to the Mysterious), in which Breton praises the 19th century Symbolists, There are notes about black humor, "André Masson's prestige" and an essay recounting his meeting with Trotsky.

Added to all of the above were abundant illustrations that mixed Picasso with Cranach and Botticelli with Dogon masks, as well as initiating a survey: "What was the most important encounter of your life?" The plethora of responses evidenced the broad circulation of the review. Skira later reprinted it in three volumes.

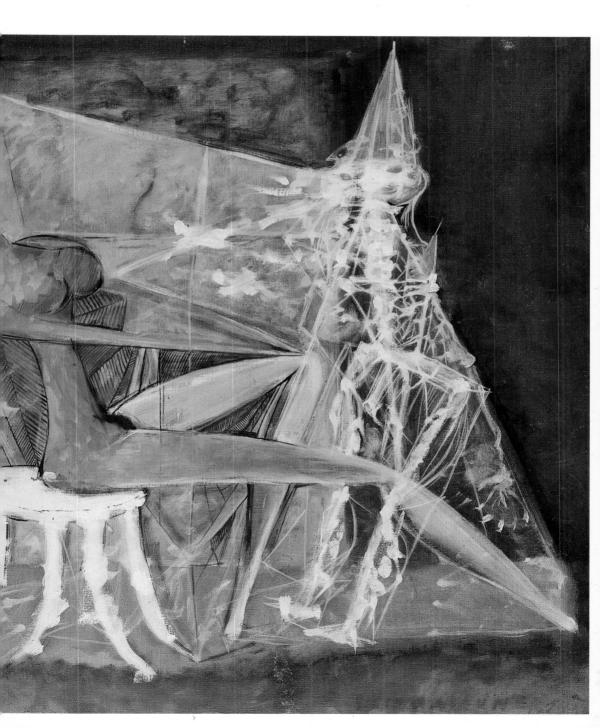

Salvador Dali

Paranoid-Critical Interpretation of the Obsessive Image of Millet's "L'Angélus", Page in Minotaure n° 1, 1st June 1933.

One can wonder at the little importance accorded to film, and the total absence of theater. Artaud was not even mentioned. Strange gaps. While Europe was seething, politics were rarely mentioned with the exception of the editors'attack on art critics (N°12-13) who called for the censorship of what was referred to as "degenerate art" (*Entartete Kunst*, Munich, 1938). Dali had himself excluded from the Surrealist group in 1939. As early as 1934, he seemed to see in Hitler another Maldoror. He was summoned before the entire group, and explanation was demanded. He answered, clowning about with a thermometer in his mouth, arguing about the orthodoxy of the movement:

He dreamed of Hitler... The events of 1934 created a diversion, but his exclusion was only a question of time. In fact, Dali was no more a catholic than an admirer of Hitler, nor even of Franco – his only true allegiance was to himself.

The Surrealists discharged at the end of 1939 would mostly flee Europe and pursue Surrealist transformations in America, where he movement was essentially more artistic than political. *Minotaure*, "the review with a beast's head" ceased publication in 1939. The world was entering into a dark labyrinth, the battle of Theseus against the men with beasts'heads.

Interprétation Paranoïaque-critique de l'Image obsédante "L'Angélus" de Millet

par SALVADOR DALI

PROLOGUE

NOUVELLES CONSIDÉRATIONS GÉNÉRALES SUR LE MÉCANISME DU PHÉNOMÈNE PARANOÏAQUE DU POINT DE VUE SURRÉALISTE

Antagonisme entre les états passifs (réve, automatisme psychique) et des états actifs systématisés. — Actualité expérimentale de l'automatisme. — De l'irrationalité, aspiration générale née de l'expérience critique de l'automatisme, à l'irrationalite concrète pré-paranoïaque. — Affirmation, contre l'attitude contemplative de l'évasion poétique, du principe productif d'action-intervention des réves dans la vie réelle. — Rappel du principe de « vérification » formulé par Breton lors de l'invention capitale des « objets omiriques ». — Le mécanisme paranoïaque confirme la valeur dialectique de l'activité surréalise dans les domaines de l'automatisme et du réve. — Il illustre et réalise d'une manière tangible, matérielle, le principe de « vérification » des contenus délirants (loin des régressions cecrcitives que la présence « systématique » pourrait déceler en accord avec la notion de « folie raisonnante »). — Le phénomène paranoïaque, contrairement aux idées générales des théories constitutionnalistes, serait en lui-même un délire déjà systématisé. — Le phénomène paranoïaque, de par sa valeur de force, de pouvoir et ses caractéristiques de productivité, de permanence et d'accroissement inhérents au fait systématique, objectiverait avec évidence l'intégration de toutes les notions dynamiques fondamentales de « processus » au « délire dialectique » du surréalisme.

Dès 1929 et les débuts encore incertains de La Femme visible*, j'annonce comme « proche le moment où, par un processus de caractère paranoïaque et actif de la pensée, il sera possible (simultanément à l'automatisme et autres états passifs) de systématiser la confusion et de contribuer au discrédit total du monde de la réalité ».

Le « drame poétique » du surréalisme résidait à ce moment pour moi dans l'antagonisme (appelant la conciliation dialectique) des deux types de confusions qui implicitement étaient prévus dans cette déclaration : d'une part la confusion passive de l'automatisme, d'autre part la confusion active et systématique illustrée par le phénomène paranoïaque.

+

On ne saurait trop insister sur l'extrême valeur révolutionnaire de l'automatisme et l'importance capitale des textes automatiques et surréalistes. L'heure de telles expériences, loin d'être passée, peut sembler plus actuelle que jamais au moment où s'offrent à nous des possibilités parallèles, résultant de la conscience que nous pouvons prendre des manifestations les plus évoluées des états passifs et de la nécessité d'une communication vitale entre les deux principes expérimentaux qui nous sont apparus plus haut comme contradictoires.

Après les coactions intellectuelles que, sous une grande charge d'émotion sthénique, Dada avait revendiquées sous la forme mécaniste d'un programme d'attitude réactionnelle (comportant, il est vrai, l'intuition de presque toutes les principales imminences), l'assimilation de l'automatisme par les surréalistes liquide toute possibilité d'« attitude » à adopter, qui serait nécessairement incompatible avec leur passivité, avec leur capitulation sans réserves devant le fait même du fonctionnement réel et involon-

taire de la pensée, cette capitulation à l'automatisme, cette soumission totale à la pensée en dehors de tout contrôle coercitif ne pouvant manquer d'apparaître, chaque jour davantage, comme la tentative la plus sensationnelle de tous les temps en vue d'atteindre à la liberté de l'esprit.

D'une manière plus cohérente, par suite plus grave que par la simple intuition des imminences dont il vient d'être question, l'automatisme dépasse et libère, dans les strictes limites du phénomène psychique, les aspirations latentes auxquelles Dada imposait pour contrainte les réactions mécaniques des dernières situations et attitudes «intellectuelles».

C'est dans le cours même, dans le cours le plus involontaire de la pensée, et en dehors de toute « obligation » poétique que cette foi en la démoralisation va s'incorporer de fait aux hiérarchies neutres, voraces et autoritaires des documents scientifiques. L'autorité ne pourra laisser d'être officiellement reconnue à la trépanation pisseuse du petit principe de contradiction, à l'érosion fine, en forme de sonnette, d'une diminuante vieille cul-dejatte, enrhumée, bretonne et électrique, merdoyant les nostalgies finies des localisations spatiales et temporelles, à la nouille-nonnade générale, à la légère morve de toupie de merde de la « causalité » molle et lamentable, pareille à une misérable montre de cendre mélangée à la nourriture et projetée avec elle par une des narines du bureaucrate moyen, confit et méditatif, à la suite d'une toux saccadée et asphyxiante et des convulsions bruvantes d'un étouffement accidentel et mécanique, provoquées par une mauvaise déglutition, survenue à la fin médiocre d'un repas solitaire achevé sans conviction sous la lumière très avancée du soir d'été filtrant irisée à travers les timides et convalescents vitrages en couleurs au motif de cigognes habillées en nourrices dans la salle vide d'un restaurant grandiose, modeste et perpendiculaire.

Considérant l'état lamentable où nous trouvons les notions fondamentales de la pensée logique, nous devons nous attendre à ce que les restes des bases mécaniques de défense des catégories décrépites du raisonnement souffrent également de cette haute et souveraine dépréciation involontaire et généreuse qui inonde fécondement, d'un regard irréparable, les terrains rassurants et confortables de l'esthétique et de la morale. Après cette submersion totale de l'abstrait-censure par l'inactivité même de la libération. comment peut-on prendre encore en considération l'évidente mauvaise foi des générations mécanistes arguant des nécessités de limitation de la productivité ainsi que de la cohérence interne non évolutive des résultats automatiques ? Comment peut-on accepter de voir mettre en balance ce prétendu manque de processus automatique et ses inconvénients épisodiques avec la déroute réelle qu'il entraîne dans la pensée - phénomène de toutes les hiérarchies coercitives du monde pratique toutes les sales « combinaisons » clandestines et transférées du désir dans le domaine crapuleux de l'esthétique, de tous ces agents provocateurs, en somme, de la pensée réaliste ? Comment hésiter, je

^{*} Éditions surréalistes, Paris, 1930.

Salvador Dali during the "bed-making contest" at the Hotel Warwick in New York the 26 April 1939.

DISPERSION

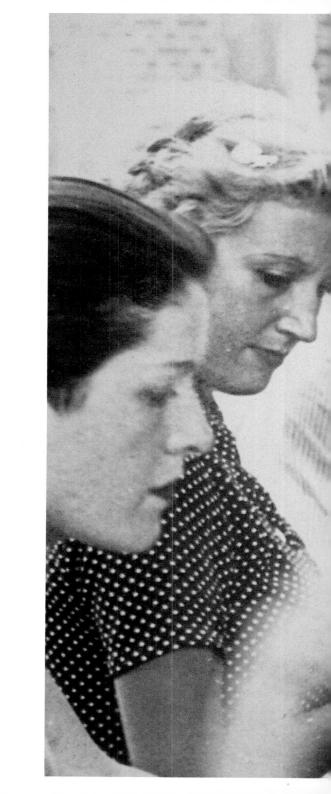

In 1939,

Breton was mobilized as a doctor, and attended a school for pilots in Poitiers. Péret had joined his regiment, but would soon be imprisoned in Rennes for anti-military Trotskyist propaganda within the army. Freud died in London in September 1939. Trotsky would be assassinated in 1940. At the time of the armistice, and exodus, Ernst and Bellmer being German were taken to Le camp des Milles. The other Surrealists met at the Air-Bel residence near Marseille (in the "Free Zone") after their discharge. They would remain housed there during the winter of 1940-41, taken care of by an American committee for aid to intellectuals, the Emergency Rescue Committee. Breton, Char, Dominguez, Brauner, Ernst, Hérold, Lam, Masson, Péret would kill time by playing cards - Tarot, "the Game of Marseille". Then thanks to Varian Fry, head of the Committee, Breton, Victor Serge, Claude Lévi-Strauss, Marcel Duchamp and Max Ernst left for Martinique in 1941.

the Communist Party in 1957:

alive... ah... oh.

"But who takes hold of my voice? Who burns my voice? Stuffing my throat with a thousand bamboo shoots. The needles of a thousand sea urchins. It's you, dirty end of the world. Dirty little dawn. It's you dirty hatred. It's you the weight of insult and a hundred years of whippings. It is you one hundred years of patience, one hundred years of my care taking, just to stay

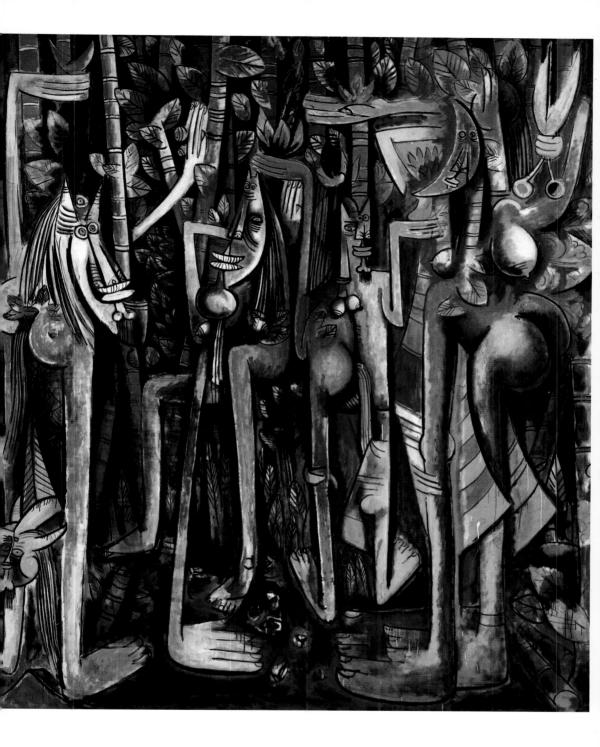

Previous page:

Wilfredo Lam

The Jungle,

1943, gouache on paper monted on canvas,

The Museum of Modern Art,

Inter-American Fund, New York.

We sing of poisonous flowers bursting in the furious prairies; the skies of love cut through with an embolism..."

In Martinique charmeuse de serpents (Martinique, Snake Charmer, illustrated by Masson) Breton seems to discover the luxuriance of tropical nature as an exterior echo of the inner sources of poetry. Does he not during these wandering years, begin to celebrate the outside world? One cannot confuse the necessity of exile with the desire to travel. The latter was never part of the Surrealist's objectives. Aside from a few epigones like Malkine, going from Cameroon to the United States by way of Oceania, then coming to Paris to die, like Émile Savitry, Pierre Roy, Paalen, Arshile Gorky, Matta and, especially, the Cuban painter Wilfredo Lam whose large forest canvas La Jungle (1943) had been admired by Breton - the Surrealists seemed in general seemed to share the idea formulated in L'Immaculée Conception: "Traveling always took me too far. The certainty of arriving has always seemed to me akin to the hundredth ring on the bell of a door that doesn't open."

In the United States, they scattered about, some in the cities, some in the country. Ernst complained of not being able to find cafés there. He established his atelier in Arizona, and began what would be quite a happy period for him. He married Peggy Guggenheim and painted L'Anti-pape (The Anti-Pope, 1942), L'Œil du silence (The Eye of Silence, 1944). He exhibited frequently. His canvas Le Surréalisme et la Peinture (Surrealism and Painting) of which we have already spoken, announced a change of tide... Masson, living in Boston said that he had discovered there "the shock of the essential" in front of Chinese paintings. His own painting drew away from the "provocative intentions of Surrealism" but continued to be nonetheless hirsute, shaggy. He fought with Breton, yet another time. Exile seemed to have brought on, especially

The Game of Marseille
1940-1941, tarot cards game.
André Breton, René Char, Oscar Dominguez,
Victor Brauner, Max Ernst, Jacques Hérold,
Wilfredo Lam, André Masson, Benjamin Péret
André Dimanche editions, Marseille.

among the painters, a revision of values. Dali was in Virginia at the home of Caresse Crosby, and wrote his auto-biographical *Vie secrète*, only slightly critically-paranoiac. Breton was fed up with this "society creature" and in 1941 formalized Dali's already de facto exclusion.

Dali's paintings during the war play with Catholicism whose baroque extremes enchanted him. This however did not alter his fundamental fascination with the phantasmagoric sources of mainstream Surrealism... That Jesus Christ was a "cheese" and that *Vie secrète* ends with "I fear that I shall die without the sky" would barely indicate a religious conversion such as Claudel's. His feverish search for a substitute mother led to a state of nervous agitation that had nothing monastic about it...

When Leonora Carrington, Ernst's former lover, finally reached the States, Ernst, whom she hoped to join, had just married a famous gallery owner... She moved

to Mexico. In addition to her fantastic fables and her paintings, her Surrealist creativity manifested itself in cooking recipes that were works of art.

Yves Tanguy had met Kay Sage, an American in France, in 1939. Declared unfit for service, he went to New York where he married her. They were to live in Woodbury, Connecticut as of 1941. Their paintings are not without affinities, as seen in Kay Sage's tragic and foggy Ghost Cities. Tanguy's painting develops in the tradition of dream-masterpieces.

The Surrealists influenced American painters they met, such as Robert Motherwell and Arshile Gorky. On the other hand, Wolfgang Paalen distanced himself. He first came to America in 1939. In 1940 he organized a major Surrealist exhibition in Mexico City, and between 1942 and 44 published six numbers of the review *DYN*. In the first issue he wrote that he "no longer believed that Surrealism would determine the position of the artist in the modern world, nor formulate objectively

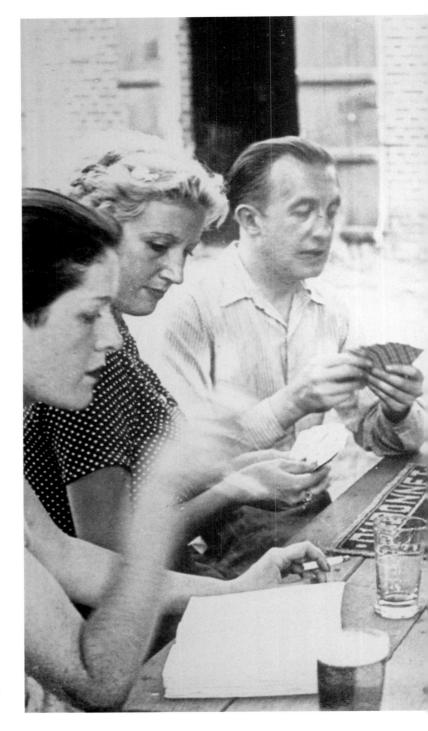

Dora Maar, Nush and Paul Éluard, Jacqueline and André Breton playing cards in 1937.

the raison d'être of art." A connoisseur of Indian art, his painting would lean towards a sort of abstract impressionism.

Breton wrote in *Prolégomènes à Un troisième mani-*feste du surréalisme ou non (Prolegomena to a Third Manifesto of Surrealism or Not, 1942): "Even after twenty years, I still feel the obligation, as in my youth, to speak out against all kinds of conformity, and in doing so, aim at a certain Surrealist conformity as well."

We should observe that in his 1941 text, *Genèse et perspective artistiques du surréalisme*, Breton rightly presents Surrealism as "artistic" according to the esthetic criteria imposed by *Minotaure*. This work, intended as a pedagogical study of the history of art in the 20th century, treats current innovations such as Pollock's drippings and the beginnings of lyrical abstraction with polite indifference.

It was in *Prolégomènes* that Breton wrote: "Not only must man's exploitation of man cease, but also man's exploitation by the supposed 'God' of absurd and provocative memory." Is it with the myth of "grands"

transparents" (that Breton presents at the end of this text) that one can maintain faith that humanity, in spite of the archaic tearing-apart of Europe, will at last find its way out of this irrationality? For the moment, the social and political myths that operate behind these battles where the "great Aryan blond" dreams of ruling the world, are those of a "free world". We can't blame Breton for contributing to the role of the radio as a means of expressing concern over this myth. While Péret, in his pamphlet Le Déshonneur des poètes (The Dishonor of Poets, Mexico City, 1945), insulted the "poètes de la résistance" that surrounded Éluard. Breton, speaker on the "Voice of America" radio broadcasts, and belligerent supporter of America allied with Stalin in the soon-to-be atomic war, brutally attacked the past errors of hard core Surrealism. Breton added his bit to the war against fascism of which he stated in a speech to students at Yale in 1942, that even the "virus" that produced it had to be eradicated.

Beginning in 1942 the review VVV continued the work of Minotaure, mixing art and anthropology. In the same year a major Surrealist Exhibition was presented by

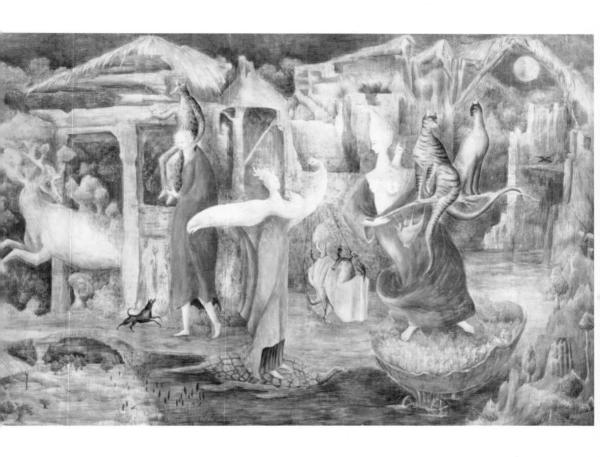

Leonora Carrington

Tuesday,

About 1917,

Formerly Edward James Foundation, Sussex.

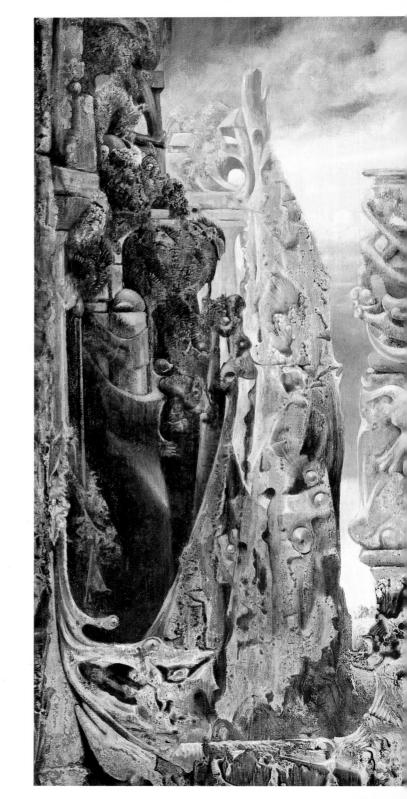

Max Ernst

The Eye of Silence, 1943–1944, oil on canvas, Washington Gallery of Art, Saint-Louis.

Arshile Gorky

Liver is a Cock's Comb, 1944, oil on canvas, Albright Knox Art Gallery, Buffalo, New York, offered by Seymour H. Knox (1956).

Duchamp along with its catalogue, *First Papers of Surrealism*. The review *View* became interested in the American version of the fantastic. A translation of the *Hebdomeros* by De Chirico appeared in January 1943, and the March 1945 issue was dedicated to Duchamp, who's personnel role along with his notoriety in America were at there highest. It was said that Matta's painting was a cross between Duchamp and Tanguy — effectively, the young Chilean's allusions to science fiction in the vague space of his canvases, seemed to be knocking on Surrealism's door. So, life goes on.

Breton met his third wife in 1943, the Chilean, Elisa Bindhoff, for whom he would write *Arcane 17* (New York, 1944). The book, written in Gaspésie (Canada) confirmed Breton's attentiveness to the colors of nature, in the perspective of a correspondence with inner unifying flux of true love.

He was criticized for the pages concerning the "femme-enfant" [Child wife] but let us not forget that for the Surrealists, childhood is the state of being closest to clairvoyance, the dawn of the spirit. It was certainly not a coincidence that Breton called his only daughter, Aube (dawn). She was the daughter of Jacqueline Lamba. *Arcane 17* brings the tragedy of *Nadja* to the level of a visionary happiness.

Kay sage

Tomorrow is Never,
1955, oil on canvas,
The Metropolitan Museum of Art,
New York.

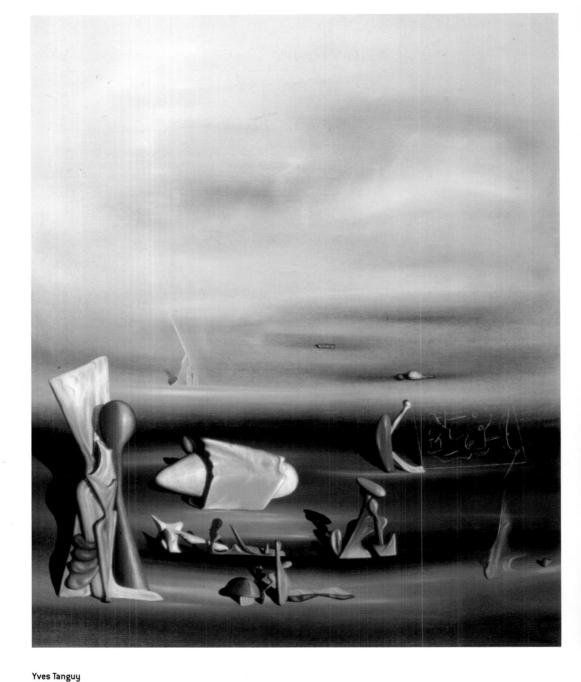

Construct and Destroy,
1941, oil on canvas,
Museo d'Arte Moderno di Ca Pesaro, Venice.

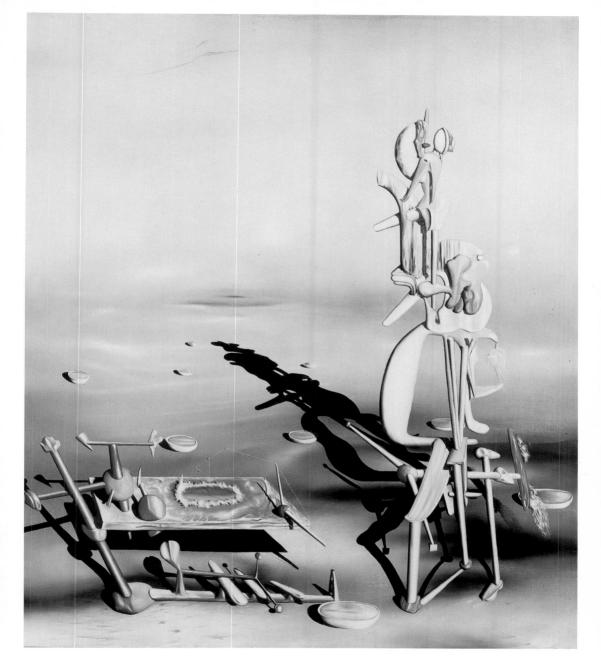

Yves Tanguy

Indefined Divisibility, 1942, oil on canvas, Albright Knox Art Gallery, Buffalo, New York.

Roberto Matta

Xpace and the Ego, 1945, oil on canvas, centre Pompidou-MNAM-CCI, Paris.

Me are here Stalls

All this time, what was happening in France? All of the "historical Surrealists" hadn't left, and beginning in 1939, young people joined in an initially neo-Dada action, that would become clearly Surrealist beginning in 1941. It was the group Réverbères, then La Main à plume, whose tract in 1941 clearly stated, "We are here to stay" (C.F. José Pierre, Tracts, vol. II, p. 5). The review Réverbères (the title was taken from Tzara) would publish five issues from April 1938 to July 1939. The public meetings in homage to Dada (May 1938) and Apollinaire were great successes. The group had created a link between the old Dadaists who vegetated at the Dôme in Montparnasse, and the young poets from the Latin Quarter. In putting on Les Mamelles de Tyrésias, they resuscitated theatre that Surrealism had ignored. They integrated music, notably jazz, to the spontaneous poetic action, breaking a strange taboo

LA CONQUÊTE DU MONDE PAR L'IMAGE

Noël ARNAUD
ARP
Maurice BLANCHARD
Jacques BUREAU
J.-F. CHABRUN
Paul CHANCEL
Paul DELVAUX
Oscar DOMINGUEZ
Chr. DOTREMONT
Paul ELUARD
Maurice HENRY
Georges HUGNET

Objet (1942).

PICASSO.

Valentine HUGO
René MAGRITTE
Léo MALET
J.-V. MANUEL
Marcel MARIEN
Marc PATIN
Pablo PICASSO
Régine RAUFAST
TITA
Raoul UBAC
G. VULLIAMY
et l'USINE à POÈMES

Il faut que la force créatrice de l'artiste fasse surgir ces images, ces idoles demeurées dans l'organisme, dans le souvenir, dans l'imagination; qu'elle le fasse librement sans y mettre d'intention ni de vouloir; il faut qu'elles se déploient, croissent, se dilatent et se contractent, afin de devenir non plus des schémes fugitifs, mais des objets véritables et concrets.

GOETHE

LES ÉDITIONS DE LA MAIN A PLUME

11, Rue Dautancourt — PARIS (XVII°)

Previous page:

Wilfredo Lam

Cover of the review View, 1942, Private Collection.

The Conquest of the World by the image, 24 April 1942, cover of a copy of La Main à la plume, Private Collection.

established by the Surrealists. Finally, Jean-François Chabrun saw the exhibition "L'art dégénéré" in Germany (summer 1938) and wrote a vitriolic review in Réverbères, N° 3. His thoughts were identical to Breton's who, at the same moment, was in Mexico City defending the free art. Chabrun realized that this defense could only be political. The future would prove that, after Réverbères, the group La Main à plume was alone in its defense of Surrealist orthodoxy (that of the Second Manifesto). During the occupation, the group would, concerning this point, take firm, semi-clandestine actions. Michel Fauré, recounts in his Histoire du surréalisme sous l'Occupation, (La table Ronde, 1982) an interview with Chabrun and Breton at the Dôme, early in 1939. Chabrun having said "Something must be done" Breton was to have responded, "It is for you to do, the young must take over!" (p.32). Was it in trying to apply these melancholy thoughts that Breton left for America? The young poets of La Main à plume were becoming more and more active politically and would pay dearly for this later, with deportation and death - eight deaths, out of fifteen or so members, among whom, Ménégoz, who was sixteen, and Mulotte, fifteen...

Breton having left, it was Péret, who would replace him for a while at the café, before managing, not without difficulty, to leave the country. The members of *La Main à plume* would always have a particular affection for Péret, and for the rigorous example he set.

La Main à plume was the publishers'logo for a series of publications, which could not appear in a regular manner due to censorship. It was also a group led by Noël Arnaud and Jean-François Chabrun. Among the members could be found the Spaniard Manuel (who had saved Péret's life during a misunderstanding with the anarchists during the Spanish Civil War — they thought he looked like a priest, and Manuel, a member of the *P.O.U.M.*, had a terrible time getting him out of there), Christian Dotremont, Marc Patin, Raoul Ubac and the painters Schneider, Christine Boumester, Gérard Vulliamy and Tita (Édith Hirshowa).

These publications were spread out until 1944: *Géographie nocturne* (Night-time Geography, 1941), *Transfusion du verbe* (Transfusion of the Word, 1941), with a text by Éluard and a contribution by Picasso, *La Conquête du monde par l'image* (Conquering of the

World by Pictures, 1942) all came out with ample participation by the Surrealists who had stayed in Europe, Arp, Delvaux, Magritte, Valentine Hugo, Maurice Henri and Georges Hugnet. The cover presented for the first time, Picasso's *Tête de taureau* (actually pictured as a "bull's head" was bicycle saddle and handlebars). Éluard contributed "Poésie involontaire et poésie intentionnelle" (Involuntary Poetry and Intentional Poetry). But having teemed up once again with Aragon who had just founded secretly *Les Lettres françaises*, he was excluded along with Hugnet.

The Surrealists gathered themselves together in *Le Surréalisme encore et toujours* (1943). In addition to these deliveries, *Pages libres* published numerous individual little plaques: *Les Malheurs du dollar* by Péret, *Pleine Marge* by Breton, and most of all, the opus *Poésie et Vérité 42* by Éluard, containing his poem "Liberté", printed for the first time in 5000 copies and distributed in the streets. The violence of the young generation loyal to Péret's spirit, also was expressed in numerous leaflets... The last publication of *La Main à plume, l'Objet* (1944) which was never released, gave the floor to young poets such as Édouard Jaguer, Marco Menegoz and Jean-Pierre Mulotte. In an unpublished notebook Mulotte writes

about the "surrealizing of music" by dipping records into soup or orange soda...

Jean-Pierre Mulotte was shot on the Austerlitz Bridge by a German that he had just insulted. Marco Menegoz, Robert Rius and Jean Simonpoli went underground in the Fontainebleau Forest and were executed with the others in a place called "le charnier" near Arbonne. Jean-Claude Diamant-Berger, a former member of *Réverbères*, would be killed in combat near Caen on 18 July 1944...

At the time of the Allies'landing, the group had suffered tensions between those favorable to drawing nearer to the Communist Party, (Arnaud, Chabrun, Simonpoli, Boquet, André Stil, who would later become the senior editor of *L'Humanité*, member of the Central Committee, and recipient of the Stalin Award...) and the Surrealists adhering to Breton's individualistic positions (Gérard de Sède, Daniel Nat, André Dalmas). This tension could not be overcome and the members of *La Main à plume* dispersed. Some of them, notably Arnaud and Dotremont would be seen again, in 1947, in *Le Surréalisme révolutionnaire*.

Before telling of the circumstances surrounding Breton's return to Paris in 1946, let us remember what life had been like for the friends who remained

Pablo Picasso

Bull's Head, Spring 1942, bicycleseat and handlebars, musée Picasso, Paris.

Clovis Trouille

My Funeral, 1940, oil on canvas, Private Collection.

ne. But personal attacks began against Antonin Artaud, Jean Carrive, Georges Limbour, André Masson and Roger Vitrac. "A policeman, a few

in Europe during the war, Picasso, Toyen, Magritte, Delvaux, Bellmer, Miró, Dominguez, Brauner, plus a few epigones like Felix Labisse or Clovis Trouille.

A word about Aragon. First, a clandestine Communist militant, his poems were primarily concerned with Elsa's eyes. We find him after the Liberation, having become an apostle of Zhdanovism. Éluard was not as involved as Aragon, and the pamphlet by Brunius and Mesens Idolatry and Confusion (London, 1944) spared the author of "Liberté", of which a translation would be published in London. This was the first attack launched by the orthodox Surrealists against the poets of the resistance (Péret's only came out in 1945). Éluard lived in Vézelay with Nusch and we know that the last word of the poem, "Liberté", was at first, Nusch's name. One can safely say that the word liberty would remain the key word throughout Éluard's life until his death in 1952. He was in fact closer to Jean Lescure's review Messages, than to Lettres françaises. Proof of this lies in his text on Bellmer's doll (1943), and those about Dubuffet and Picasso.

Picasso, hence a member of the Communist Party (to Breton's consternation), made an exhibition in 1944 that would remain in the annals of the Salon d'Automne. His freedom would later be a thorn in the

side of his hard core Stalinist friends. And the others? Toyen made drawings that reflected the tragedy of the era, Le Tir (The Shooting, 1940), and Cache-toi guerre (War, Hide Yourself, 1944). Her sado-masochist paintings are summarized in canvases such as Au château Lacoste. Magritte stayed in Belgium and joined the Belgium Communist Party en 1945. Linked with the "surréalistes révolutionnaires", he broke off with Breton once again. Paul Delvaux painted calmly during the entire period and had a retrospective in 1944 at the palais des Beaux-Arts in Brussels. The women that he painted, Éluard would write, are "left to their desting of knowing nothing of themselves." So it was with this artist. Felix Labisse, whose female nudes are often cruel, began to paint in 1938 and Desnos dedicated an homage to him in 1945. As for Clovis Trouille, the representative of a "popular Surrealism" he painted a great deal during the occupation: Dialogue au Carmel (Dialogue at Mount Carmel, 1944), Mes funérailles (My Funeral, 1945), Stigma Diaboli (1960), where one recognizes André Breton...

Bellmer, released from the camp des Milles in 1940 threw his German passport in a gutter in 1941. A refugee in Toulouse, he remarried. He illustrated *L'Histoire de l'Œil* (The Story of the Eye), by Bataille, and

René Magritte

Philosophy in the boudoir, 1948, gouache, Private Collection.

his sharp engravings of the sensuous intertwining of feverish anatomies, would make him famous. In 1946, separated from his wife, he met the young philosopher Nora Mitrani... Joan Miró left Varengeville and sought safety in Barcelona, his place of birth. His gouache Constellations (1940-41) made their way to André Breton in America. Victor Brauner, at the time, a refugee in Gap (France) came out of his Chimères (Chimera, 1939) period and entered his period of flat wax surfaces: Première solitude (First Solitude, 1943). Hans Arp, who had emigrated to Switzerland, was shocked by the accidental death of Sophie Taeuber in 1943. He too would be scarred by the trials of solitude. On the other hand, Desnos, having escaped Surrealism long ago, was deported as a Communist resistant and died of exhaustion and sickness upon his release from the Térézine concentration camp, 8 June 1945. René Char, under the name of Captain Alexandre, directed an underground resistance group in the Vercors. He was to publish Feuillets d'Hypnos (Hypnosis Pages) in 1946; in 1948 Seuls Demeurent (The Only Left), and in 1953, Lettera amorosa (Love Letter, later used in La Parole en archipel [The Word as an Archipelago, 1962] with an epigraph taken from the Lettera amorosa by Monteverdi).

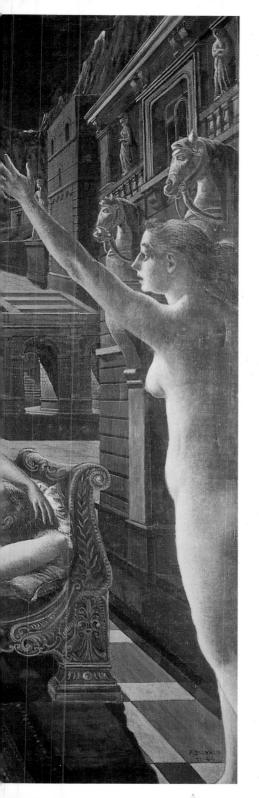

Paul Delvaux

Venus Asleep, 1944, oil on canvas, Tate Gallery, London.

Hans Bellmer

Nude from the back with Spike Heads, 1961, charcoal, red pencil, white gouache highlights on paper glued to cardboard, centre Pompidou-MNAM-CCI, Paris.

The most important poet of the young generation of Surrealists, René Char, who's *Le Marteau sans maître* (The Hammer without a Master, 1934 and 1935) served as the text for Pierre Boulez's music, had written in 1932 (*SASDLR*, N°4, p.12): "Poetry incorporates itself in time and absorbs it. Where the white night ceases, the white night continues. But that the clairvoyant exterminates the believer and the Surreal suddenly appears, moves in, imposes itself. A world of passion from which we can't escape, that we no longer desire to escape." After the war, he lived in seclusion in L'Isle-sur-Sorgue. Until his death in 1988, he continued to produce a body of mysterious and violent works:

"Time as a sub-work, years of affliction... Natural right! In spite of themselves they will once again give life to the Work of all admired times. I cherish you. Soon he will be without the ambitious one who stays unbelieving in the woman like the hornet battling with cleverness less and less spacious. Yet I cherish you who can turn away the heavy bait of death.

This was, blessed world, a changed month of Eros, that she illuminated, built from my being, the conch of her belly: I've mingled them forever. And it was at such a second of my apprehension that she changed the blurry and abhorrent path of my destiny into a path of for the furtive happiness of the land of lovers." (Lettera amorosa, in La Parole en archipel, 1962, Dédicace).

Victor Brauner

Cup of doubt,

1946, wax on cardboard,

Museu de Arte, Sao Paulo.

Joan Miró

Numerals and constellations in Love with a Woman,

12 June 1941, gouache and turpentine painting on paper,

Art Institute of Chicago.

Offered by Mrs Gilbert W. Chapman (1953).

Biching

So, Breton is back. Upon arrival, he found those Surrealists who had stayed in France scattered and scarred by the ordeal. His perspicacity had led him to write in *Arcane 17*: "We came to quick conclusions trying to build a bridge between the Paris of early 1940 and the Paris of 1944, but only an idiot could maintain the illusion that they are the same city." Too much blood had flowed under this bridge and "L'Affiche rouge" of the Manouchian group (those of the French Communist Party who had been shot) had no place in Breton's memory. He too had changed. More anti-Communist than ever, he came to a country where de Gaulle included Communists in his government.

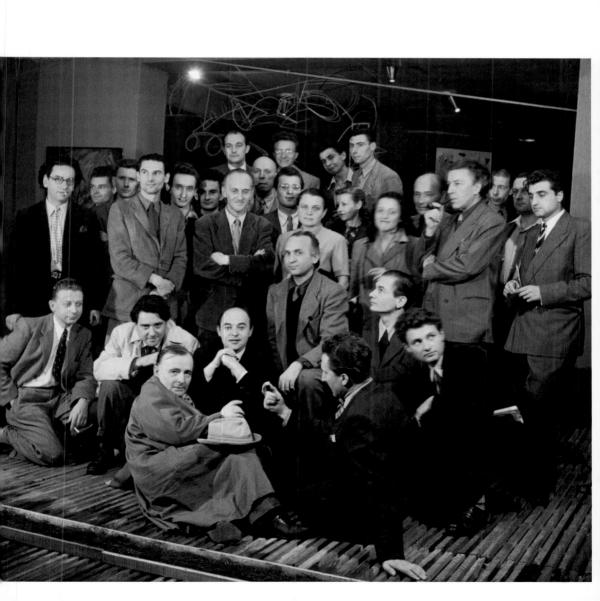

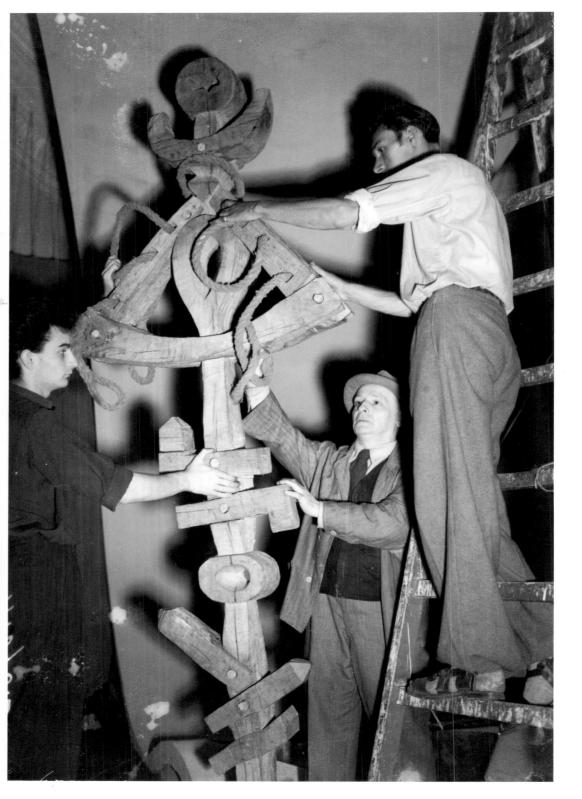

Previous page:

Denise Bellon

The Surréalist Group at the 1947 exhibition at the galerie Maeght, galerie Claude Oterelo, Paris.

1947 Exhibition at the galerie Maeght, A Totem of Religions, by Frederick Kiesler.

He gave his first Parisian interview in Figaro Littéraire. This was considered unpardonable by the young poets that had just barely left La Main à plume, for Yves Bonnefoy's La Révolution la nuit, or for Les Deux Sœurs, by Dotremont, and by other smaller groups in mourning equally scarred by the war. The spectacle of the deportees walking the streets of Paris in their prison uniforms, the photographs of the Shoah's death camps provoked an emotional shock... The Communists proclaimed themselves "the party of those shot". It was the bombast and pomposity of the Liberation. It was the obscene ritual of shaving the heads of women who had slept with the Germans, against which Éluard spoke out:

Comprenne qui voudra moi
Moi mon remords ce fut
La malheureuse qui resta
Sur le pavé
La victime raisonnable
À la robe déchirée
Au regard d'enfant perdue
Découronnée défigurée
celle qui ressemble aux morts
qui sont morts pour être aimés...

Understand he who would like
My shame was that
Of the poor girl left
On the street
The simple victim
With the torn dress
With the gaze of a lost child
Dethroned, disfigured
She who resembles the dead
That are dead for having been loved...

Yes Paris had changed and it was a problem for Breton to have to gather together all those scattered members, while the youth no longer seemed to have need of him.

What happened to the Liberation? Three important facts shed light on these turbulent times, a sort of aborted May '68, lost in the reconstruction Republican Order. Three important facts concerning Surrealism:

- 1. Artaud's presence;
- 2. The 1947 exhibition at the galerie Maeght;
- 3. The *Surréalisme révolutionnaire*, shattered by the return of the French Communist Party to *Zhdanovism*, and the beginning of the Cold War.

Artallyesence

For the Surrealist movement of the post-war period, Artaud's presence was more important than Breton's return. The tragedy of the death camp survivors seemed to find an echo in the tortured voice of the Rodez survivor. Artaud entered this disgusting asulum in 1943. He became the prey of Dr. Ferdière, a wellmeaning man who held the poet in "terrified esteem" and subjected him to multiple electric shock treatments, a therapeutic practice in style at the time. The only effect would be the ruin of Artaud's health. Adamov and Marthe Robert went to see him and were horrified. They decided to try to get him out of this misery. Adamov managed to organize an auction with the help of members of Parisian elite. This was intended to reassure the Administration who refused to release a penniless mental patient.

Jean Paulhan managed to have him freed and on 28 May 1946, he arrived in Paris. Dr. Delmas had accepted to take him on in lvry, where he could freely come and go. On 7 June an evening in honor of Artaud was organized at the Théâtre Sarah Bernhard. Celebrities of the theater world read his works, while he wandered about the theater outside. He had not been allowed in. Colette Thomas brought the audience to tears with her reading in the dark, during an electrical

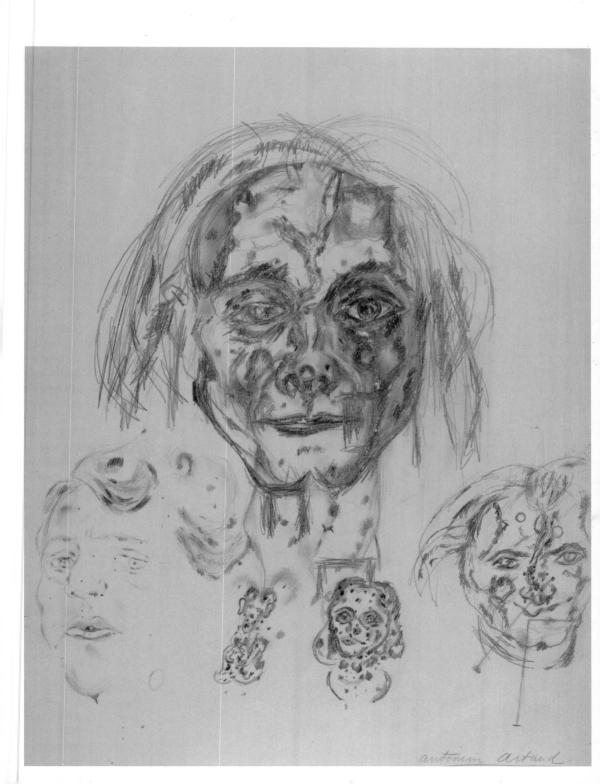

Previous page:
Antonin Artaud
Self-portrait,
II May 1946, pencil on paper,
centre Pompidou-MNAM-CCI, Paris.

blackout. Another evening was organized at the Vieux Colombier in 1947 so that Artaud could express himself in person. Alone on stage, he had great difficulty presenting his incantation before a room full of well-to-do and inquisitive people. It was a flop... It was in Ivry that Artaud put the final touches on Artaud le Momo (1947) and wrote Van Gogh, le suicidé de la société:

Le corps sous la peau est une usine surchauffée et dehors le malade brille, il luit, de tous ses pores, eclatés, Ainsi un paysage de Van Gogh

à midi...

Under the skin, the body is an overheated factory and outside the patient shines, he glows, from every pore, split open,
So is a landscape by Van Gogh at noon...

He also wrote his famous radio piece *Pour en finir avec le jugement de Dieu* (To Get the Judgement of God Over With), which was rejected in February 1948 in spite of massive protests. On 4 March, Artaud died in Ivry. He was found in the morning, on the floor at the foot of his bed.

Adamov, Marthe Robert, Henri Thomas, Jacques Prével, Henri Pichette were his last friends. And even if Adamov had joined the Communist Party along with Guillevic, Vaillant, Tzara and the Comité national des écrivains (C.N.E., National Committee of Writers), the fact remained that Artaud's voice kept up a form of tragic Surrealism, linking the survivors of La Main à plume to the apparently optimistic, fundamentally desperate supporters of Surréalisme révolutionnaire. The group had protested against Surrealism's turning towards playful superstition (superstition ludique) and the "new myths" symbolized at that time by a big group show in Paris at the galerie Maeght:

"Le Surréalisme en 1947" (Surrealism in 1947). On his way back to Europe, Breton, who had stopped in Haiti at the invitation of Dr. Mabille (it was said that his lectures incited riots...), was impressed by Voodoo rituals, and had brought back to Paris a form of Surrealism more esoteric than ever. This was evident in

Victor Brauner The Wolf-table, 1939-1947, wood and stuffed fox elements, centre Pompidou-MNAM-CCI, Paris.

the exhibition of 1947. The spectators were required to follow an initiation path, of which the twenty-one steps represented the twenty-one mysteries of Tarot. The "Hall of Superstitions" then took one through purifying rain, towards a "Labyrinth" with niches wherein lay thirteen objects "susceptible of endowed gifted with mythical life" the *Tigre mondain* (Fashionable Tiger) by Ferry, the *Soigneur de gravité* (Caretaker or 'Juggler'of Gravity) by Duchamp, the *Loup-table* (Wolf-Table) by Brauner, and *Les Grands Transparents* (The Large Transparents), by Hérold, etc. The catalogue contained 87 names from 27 countries, and the deluxe copies were crowned with a foam rubber breast, marked "please touch"...

In all evidence Breton had managed to gather together a few old friends such as Duchamp, along with the younger generation whom he'd attracted — Ferry, Bédouin, Legrand, Dax, Duprey, José Pierre... We will find them again in 1952 in the review *Medium*. Many were those who would have preferred overt revolutionary action rather than the "occultation" that Breton proposed beginning in 1929. This action had been repressed, and would later become explosive, with the mere word "liberation".

Jacques Doucet

Un... deux... trois... quatre..., 1947, gouache on paper, Private Collection.

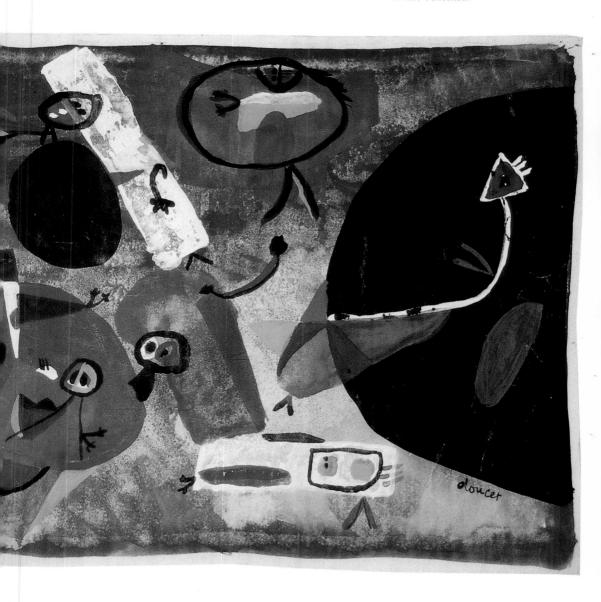

Former member of *La Main à plume*, Christian Dotremont founded a "revolutionary Surrealist" group in Brussels, in 1947, which was immediately taken up and expanded by Noël Arnaud in France. The Belgian group had around twenty members, among whom were Magritte, Chavée, Mariën, Nougé, Louis Scuttenaire. The French group added the 18 signatories to the *Manifeste du surréalisme révolutionnaire*, among them, Suzanne Allen, Yves Battistini, Pierre Desgraupes, Pierre Dumayet, Édouard Jaguer, Hubert Juin, Jean Laude, and René Passeron...

Le Surréalisme Révolutionnaire

REVUE BIMESTRIELLE PUBLIEE PAR LE BUREAU INTERNATIONAL DU SURRÉALISME RÉVOLUTIONNAIS

Suzan Allen - Else Alfelt - Noël Arnaud - J.M. Atlan Raymonde Aynard - Yves Battistini - Ejler Bille - Francis Bott Kujahn Blask - Paul Bourgoignie - Marcel Broodthaers Max Bucaille - Aimé Césaire - Achille Chavée - Bob Claessens Paul Colinet - Paulette Daussy - Raymond Daussy Pierre Desgraupes - Oscar Dominguez - Christian Dotremont Jacques Doucet - Pierre Dumavet - Louis Dumouchel Paul Frank - Henri Goetz - Benjamin Goriély - Hamel Guita Jacques Halpern - Irène Hamoir - Marcel Havrenne Henry Heerup - Walter Hoeber - Michel Holyman Josef Istler - Ejill Jacobsen - Robert Jacobsen - Edouard Jaguer Johannes Jensen - Asger Jorn - Lucien Justet - Jacques Kober Milos Korecek - Ludvick Kundera - Félix Labisse Bohdan Lacina - Jean Laude - Jules Lefranc - Marcel Lefrancq André Lorant - Zdenek Lorenc - Albert Ludé - René Magritte Marcel Mariën - Rouben Mélik - Tage Mellerup - Franz Moreau Richard Mortensen - Georges Mounin - Jorgen Nash Jean Noiret - Paul Nougé - Erik Ortvad - René Passeron Armand Permantier - Carl Henning Petersen - Gabriel Picqueray Raymond Queneau - Vilém Reichmann - Léonce Rigot Viggo Rohde - Madeleine Rousseau -Jens-August Schade - Louis Scutenaire - Armand Simon René de Solier - Pierre Soulages - Roger Steinhart Boguslaw Szwacz - Tibor Tardos - Erik Thommesen Vaclay Tikal - Tristan Tzara - François Van der Drift Louis Van de Spiegele - Vaclav Zykmund

Previous page: Cover of the review Le Surréalisme révolutionnaire, n° 1, March 1948, Private Collection.

Names of collaborators of the review Le Surréalisme révolutionnaire, n° I, March 1948, Private Collection.

Let us look at the attempts of the "historical Surrealists" of 1930 – to reconcile the two central concerns: responsible political action and free artistic creation - who thought they could profit from the euphoria of the Liberation to accomplish this task. The exhibition Prise de terre was held at the galerie Breteau in 1948, extremely open, from Labisse to Hartung, not to mention Atlan. Le Surréalisme révolutionnaire review (N°1, Mars 1948) presented an broad table of contents, in which one noticed, in addition to the Belgians already mentioned, Tibor Tardos (Hungary), Zdenec Lorenc (Czechoslovakia), Raymond Queneau, Tristan Tzara, Aimé Césaire and numerous artists such as Goetz, Bucaille, Asger Jorn, Mortensen and the sculptor, Robert Jacobsen (Denmark), Atlan, Doucet, Francis Bott... The review didn't make it to the second issue. However, a Bulletin international du surréalisme révolutionnaire played the role of a bridge. At the presentation of the Malheurs d'E, by Jean Laude, a pianist played Webern's Variations op. 27, and so-called abstract paintings widened Surrealism's horizons. A memorable series of lectures, mostly Dadaist, took place in the Salle de géographie in Saint-Germain-des-Prés. The subjects discussed were eroticism and freedom, film and music. The rowdy audience got to see

fist fights between Breton's Surrealists and the Lettristes, then quite the thing. Success was obvious...

In tracts such as "La cause est entendue" (The Cause is Heard), Surréalisme révolutionnaire was heavily insulted by followers of Breton. In the same manner, on the other side, by the Stalinists. The "Party intellectuals" (Casanova, Garaudy, Aragon and his entourage), were overwhelmed, furious. Their dogmatic seriousness would, as early as 1948, return to Zhdanov's theory of art as a political weapon. They couldn't accept those who claimed to be French Communist Party members without its approval. Motivated by Arnaud, the French group decided to disband. The "cold war" began. Each went off to pursue his own life — Arnaud to the "Collège de Pataphysique", Jean Dubuffet and Boris Vian, and others such as Edouard Jaguer, would found the review Phases, etc.

Dotremont, however, managed at the end of 1948 to bring together, *a parte*, representatives from COpenhagen, BRussels, and Amsterdam, founding the Cobra movement, dedicated essentially to the joy of artistic creation, in much the same way that Minotaure had followed SASDLR...

PERSISTENCE

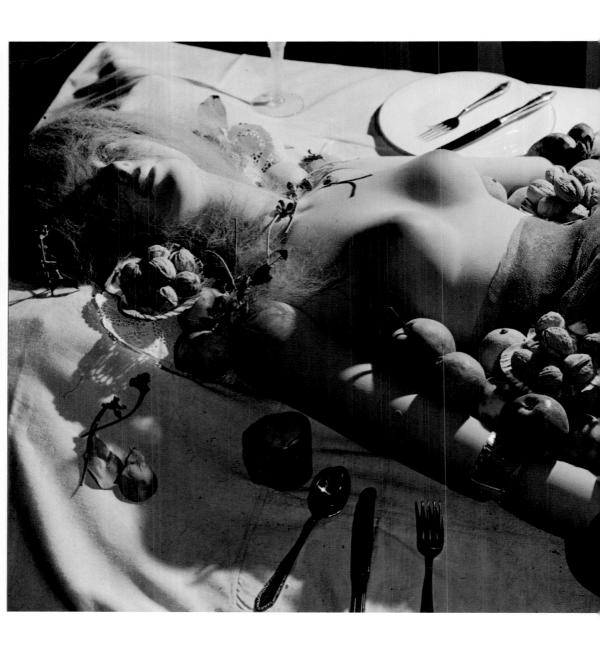

At the end of the occupation,

the major intellectual influence was not Surrealism but Existentialism. And this, in spite of the publication of Maurice Nadeau's *L'Histoire du surréalisme*, (Nadeau had been accused by the orthodoxy of having buried Surrealism), in spite of literary reviews such as *Fontaine* (Max-Pol Fouchet) or *Les Cahiers du Sud*. Sartre had published *L'Être et le Néant* in 1943.

Denise Bellon

Cannibal's feast,
Detail. At the exhibition EROS
at the galerie Daniel Cordier
in Paris in 1959-1960,
galerie Claude Oterelo, Paris.

Frictions of Mic

He founded the review *Les Temps Modernes*, where one could find Masson and Leiris. The success of the review, heavily involved with current politics and philosophy, may explain in part the marginalization of Surrealism. Breton soon be speaking of the theme of occultation. The word can be understood in two ways: Surrealism's rapport with the world of "occult sciences" or the relegating of Surrealism to an obscure part of society where it slowly loses its bearings.

The 1947 exhibition at the galerie Maeght corresponds to the first use of the word. Surrealism's plunge into an erotic culture, which would culminate in the exhibition *EROS* at the galerie Cordier in 1960, corresponds to the second. It is remarkable, in fact, that one must wait until 1956, thus ten years, for the review *Le Surréalisme, même* to come back to a full publication of the movement's positions. In 1948, *Néon* was only a photocopied newspaper filled with drawings that pushed the texts off into the margins.

Thumanullo Hill 11111111 norir l'être être rien

HENRI HEISLER

VERA HEROLD

CLAUDE TARNAUD

Jei, rencontre des êtres tendant à un même profil d'équilibre.

Amitil exaltante au sein d'un groupe étectif se situant au delà des idées, au delà du grégaire * Certitude que l'amalgame de certains inclividus, point focal agrissant peut recréer de moncle. * Tout acte n'est valable qu'en fonction du SENSIBLE qu'il implique et qu'il projette ! Faire de chaque gestum gramm d'amon NOUS VOULONS ÉTRE DES PRISMES À RÉFLEXION TOTALE POUR TOUTES LES LUMIÈRES, SURTOUT CELLES QUI NOUS SONT ENCORE INCONNUES

VICTOR BRAUNER ANDRE BRETON JACQUES HEROLD TOYEN

nunéco 1

ARIS JANVIER 1948

Ligne asundant

it emparise de vouvele et de vous y inne prendiment forte es amoutement le fet de la penote de etcim en fut de la penote de automonent févoral, dont tout komme des framers ages event to la frair externé vit son le de des montages, peace messans in des montages, peace messans in the to to telesans et été on ya qui te frajecent augunt la me

the rea with your law Dha, may philoconside restricted by depressions were determined to proceed the commencation of the manifester of the connection of the connection of the control of the party of the control of th

was permanent. Les contacts primerations and compile to make the makes pi its on a cut it is assert anothering have makes pi it is a clarific. It is important a per permanent of the compiler permanent of the compiler permanent. It is manufagic pertain a cut if a communique permanent of the compiler perm

vant het assure la totale liberti de moums au-bourd get titl door fauncie. Conscietate da de set van gen it som lage, politigue timble, comme l'andagie ingestien, militere en favour de la contention et un monde amouffe & pute de ne de tout entire parocure de la révoir som le tout entire parocure de la révoir som mais élle se mondieur des som securion de !

statistical programme being specific professional profession programme being being desirable files. He der wiede being aus paint places to the little for the state of the sta

So disember 1947. 17 wi Bres

It y aura CONTRE il y avait It y aura COMME il y a

quant aux recours d'une tells architectoniques de même que l'économie politique est la science de production, de répartition et de connomation des richesses, selon des lois d'ememble déterminés, l'économie poétique est l'évéranchement dialecti-que de la poésique travalorise, en vue d'une éman-cipation perpétuelle, les écuations et les pas-sions, les plaisirs et les feux,les travaux et les nura-muistant une sélection ricpursusement payjours, suivant une sélection rigoureusement psy-chologique. Ce sont là deux états du mouvement spatial, qui ne sont en aucun cas solidaires, qui s'excluent même parfois l'un l'autre ; le pragma-

Treger Hirold Continue politique n'ayant pas le mointre pouvoir d'aution sur la réalité pofitique de paut alse penser à juste titre que le direction de paut alse penser à juste titre que de mains serait de aires dépendre le politique du potitique on rest pas un poète à réaliser l'applique de la mieux venu et plus inspirant à restre, an eseraite qu'éclairer le domnées inconceientes , appliquer la lucidité , lever le vautour au milé, le divergence de along virent de se aux deux d'applique la lucidité, lever le vautour au milé, le divergence de along virent de se aux deux de la conseine tes, expliquer is sociate, lever to "suctour au ind . La divergence de plans vient de ce que dans toute économie poétique la notion du plus grand nombre est , qu'on le veuille ou non , épisodique et transitoire: le monde véritable se joue sur le thé. Stre de l'enfance, où le singulier est la conditi-on première de l'universel la notion de mutualité doit être alors substituée à celle decollectivité,

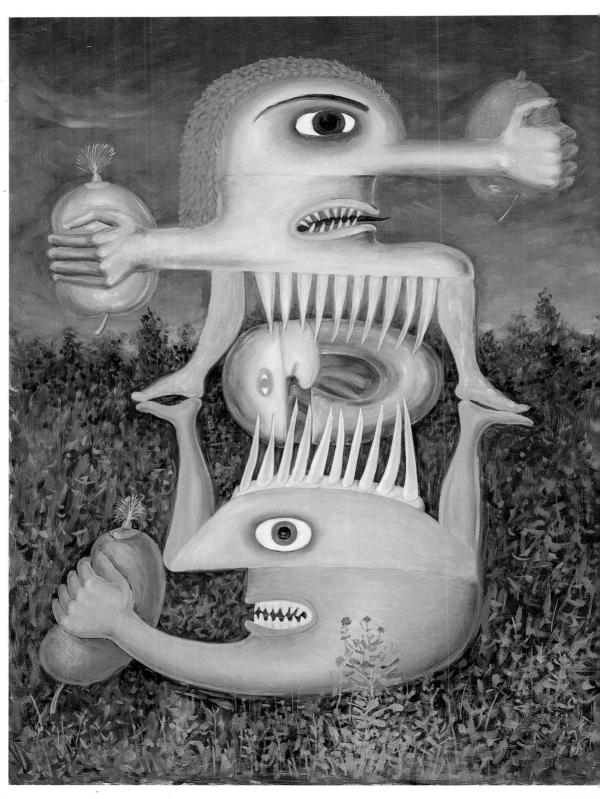

Previous page:
Cover of the first issue of Néon,
1948,
Private Collection.

Victor Brauner

The Unhappy Experience,
1951, oil on canvas,
centre Pompidou-MNAM-CCI, Paris.

One could find one of Breton's important works (in N° 1, 1948) later used in *La Clé des champs* (1963): "Signe ascendant" (Rising Sign):

The most beautiful light shed upon the general, obligatory meaning that an image worthy of its name should take, is given to us by this Zen apology: Out of Buddhist goodness, one day Bashô ingeniously modified a cruel Haiku, composed by his disciple, Kikakou, full of humor. He had said: Pull off the wings of a red dragonfly/a chillipepper. Bashô put in its place: A chilli-pepper/give it wings/a red dragonfly.

Néon ceased to exist in 1949. Breton and Péret were surrounded, among others, by Sarane Alexandrian, Heisler, Bédouin, along with Brauner, Toyen, Hérold and Lam as illustrators.

A certain Garry Davis interrupted a meeting of the General Assembly of the United Nations which was gathering in Paris (November 1948), in order to proclaim himself a citizen of the world. Numerous intellectuals, the Surrealists among them, supported him. An unfortunate adventure which would be short-lived — a generous utopia incarnated by a fragile herald. Breton himself put an end to it in October 1949, much

to the dismay of his anarchist friends. Another strange affair made headlines and put the critics of the newspaper *Combat*, Maurice Nadeau, Pascal Pia, Maurice Saillet in a difficult position. The manuscript of *La Chasse spirituelle* (The Spiritual Pursuit) by Rimbaud had supposedly been found; in the end it turned out to be a fake. Breton (let us note the quality of his judgement) had immediately realized through "critique interne" (gut feeling) that the text could never have been written by Rimbaud. *Flagrant délit* recounts this unfortunate story.

Between the apolitical who gathered around Brauner and those who persisted, with Breton, to pretend to be in phase with the dark events of the time (massacre in Madagascar, the beginning of the Vietnam war, uprisings in Algeria) the tension was thickening. The split happened on the day that the group pronounced Matta's exclusion "for moral ignominy" (it was a sentimental affair linked with Gorky's suicide). Brauner and Jouffroy left with Matta.

Was it in order to re-establish cohesion in the group that Patrick Waldberg and Henri Pastoureau attacked Breton, regarding a lecture by Carrouges: one would

be had to believe that the Catholics were trying to recuperate Surrealism. With Jules Monnerot, Le Surréalisme et le Sacré (Surrealism and the Sacred, 1945), Pierre Klossovsky, Sade mon prochain (Sade My Brother, 1947], and Carrouges, A. Breton et les données fondamentales du surréalisme (A. Breton and the Fundamental Facts of Surrealism, 1950), an attempt was made to apply a lawyer's argument to the demonstration that to be an atheist was to serve God, that to insult God was, in fact, to love him... In short, the Surrealists brought back their anti-religion theme in the tract, À la niche des glapisseurs de Dieu (All Yelpers of God to the Kennel, 1948). Having been involved with the group, Carrouges was excommunicated. Everything fell back into place after the publication of Haute Fréquence, which restated Surrealism's fundamental positions against all fideistic kneeling. The anarchists rushed to publish this important text in Le Libertaire, the newspaper in which the Surrealist's pamphlets were published between 1951 and the end of 1953.

The newspaper Arts published several interventions by the Surrealists, one against the Mexican painter

D. Alfaro Sigueiros, who boasted to have participated in the assassination of Trotsky, another in favor of the poet Germain Nouveau, considered to be on equal par with Rimbaud and Lautréamont, and most of all a response to Camus's book L'Homme révolté, where Surrealism is attacked head on, Rimbaud ridiculed, and Lautréamont considered "banal"... In fact, Camus stood up against "absolute revolt" yet his thinking is not precise enough to be able to distinguish in this formula, the revolt on one hand, which is vital to the critical mind, and on the other, the absolute, which could also be called fundamentalist. Thus, Camus would call for a "measured revolt". He should have commended the Surrealists for having had, with regard to action, done just that. For the verbal excesses, which carry to the extreme the cry of revolt, belong only to that emotional margin with which, Bergson had said long ago, all "moral heroes" go beyond their thoughts in order that they be lasting. Retrospectively, this polemic seem completely fallacious.

Another quarrel: a radio program presented Alfred Jarry as a "Christian poet". To consider the "La passion du Christ considerée comme un course de côte" (Christ's

Passion Considered as a Hill Climb Race) guoted in the Anthologie de l'humour noir, by Breton) a liturgical work, is a result of the famous Jesuit dialectic, so scathingly rejected by Pascal. In short, the Surrealists answered with a text, Bas les Masques, bas les pattes! (Down with Masks, Down with Paws!), and in the review Arts Péret asks the question: "Is Jarry a Christian poet?" The answer of the entire Parisian intelligentsia was negative. End of discussion. With regards to the controversy over "realist" Soviet art, the underlying question was: "Why is contemporary Russian painting being hidden from us?" and after Aragon's response, Breton's last word: "Socialist Realism as a means of moral extermination." A major exhibition was organized by James Johnson Sweeney (1952) at the musée d'Art moderne de Paris – Seurat, Gauguin, Cézanne, Van Gogh, Renoir, Münch, Picasso, Matisse, Kandinsky, De Chirico, Mondrian, Chagall, Derain, Balla, Juan Gris, Braque, Malevich, Dali, Ernst, Matta, Masson, Miró, Tanguy, Henri Rousseau the "Douanier" with five canvasses among which Le Rêve (The Dream): This wave of talent did, early on, sweep away a few cob webs.

And We shall have u

We shall have understood that during these polemics, the painters went along their ways without the need for any group at all. The time for retrospectives began for the eldest: Picabia for example, in 1949. For the others, freedom in creation didn't cease developing. Brauner's individuality became high handed. He signed his paintings Victor. Joking in part, he practiced "pantheism of the self". In a Surrealist issue of the review View [1941], the text that he had sent to America proclaimed: "I am the birth of the object. I am the end of the object. I am the specter and the apparition. Everything starts and disappears with me, in me..." Yet in 1948 came Totem de la subjectivité blessée (Totem of Wounded Subjectivity) and the thirty seven paintings of the *Onomatomanie* series, then the "période des rétractés" (time of those withdrawn). Brauner did not move towards an expression of happiness as did Masson and Ernst. Solitary and dark, he died the same year as Breton, 1966.

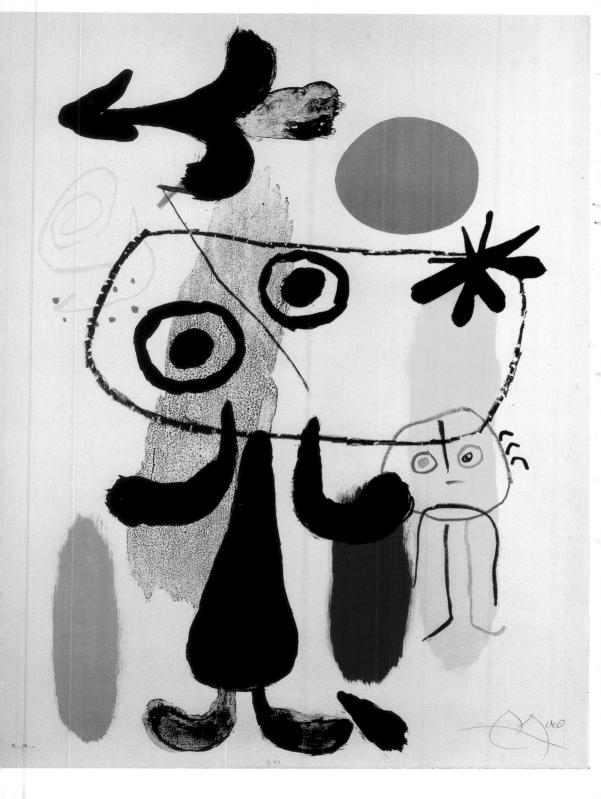

Previous page:
Joan Miró
Figure against a Red Sun II,
1950, lithograph,
Private Collection.

Aloïse

Rodolf d'Autriche Fribourg,

Detail, colored pencil on paper,

Before 1964, musée cantonnal des Beaux-Arts, Lausanne.

Between 1946 and 1950 first rate works proved the persistence of pictorial Surrealism – *Le Cheval de Troie* (The Trojan Horse, Dominguez, 1947), *Agonie* (Agony, Gorky, 1947), *Umbral* (Lam 1950). Matta's work developed in the company of Gordon Onslow Ford, an Englishman. His exclusion from the group had no influence on his painting which became darker and darker because of, he said, "the horrible crisis of society." *Les Aveugles* (The Blind), or *Every Man a King* (1947), announced his later political paintings.

Max Ernst married the young painter Dorothea Tanning in 1946, in Los Angeles. The couple returned to France and settled in Touraine in 1954. Ernst's painting toned down into a sort of abstract Impressionism, close to Bazaine. Major retrospectives in Paris and New York finally give him the notoriety he had waited for so long. His Grand Prize in the 27th Venice Biennale in 1954 earned him sarcastic comments from Breton.

Masson published a collection of his articles from *Temps modernes* under the extremely significant title of *Plaisir de peindre* (The Pleasure of Painting). Yet, the style of *L'Homme ivre* (The Drunkard, 1962) remains aggressive. We will see that Masson's old age, as is often the case with painters, corresponded with intense creativity. An example is the ceiling of the

Odéon theatre in Paris, painted in 1964. Miró would go the United States for the first time in 1947. His fame was becoming worldwide. He shared the prize in Venice with Arp and Ernst in 1954. It is evident that his paintings are not "windows" but in fact airy blueprints where one must follow the path of the lines, and not look for representations. For example in Joie d'une fillette devant le soleil (Joy of a Little Girl in the Sun). Let us add that in 1948 the Compagnie de l'Art brut was founded, led by Jean Dubuffet, Breton, Michel Tapié de Celeyran, Paulhan, Noël Arnaud. One must underline the theoretical importance of "l'Art brut" product of a non-cultural creative activity, by autodidacts. The company included some big names: Aloïse, Gaston Chaissac, the clairvoyant Joseph Crépin, André Demonchy, the mystic anarchist Miguel Hernandez, Miguel Vivancos (a former colonel in the Spanish Republican Army, hero at Teruel and Puigcerda: he painted the tender Jardin des oiseaux, Garden of Birds, in 1954), "Scottie" Wilson, Adolf Wölffli - joined these "naïves" such as Benquet, Ivan Généralic, or Séraphine de Senlis, mentally ill, obsessed with virginal pregnancy, who's works today are in the musée d'Art moderne. In a text linked with the founding of this Compagnie, André Breton wrote: "I am not afraid BONJOUR MADAME

Previous pages:

Francis Marshall

Bonjour Madame,
Shutters, curtains, burlaps, paint,
height 1,80 m.,
La Fabuloserie,
Alain Bourdonnais Collection.

Francis Marshall

The Doors, 1989, assemblage and acrylique, La Fabuloserie.

to submit the idea, that seems paradoxical only on first hearing, that the art produced by those we put today into the category of the mentally ill, is in fact a reservoir of moral healthiness. In fact, it escapes everything that tends to blur our perception and is related to exterior influence, to calculating, to success or disappointment encountered on the social level, etc. Here, the mechanisms of artistic creation are give free reign. Because of a striking dialectic effect, the confinement, the renouncing of any profit and all other forms of vanity, in spite of what each individually presents as pathetic, guarantee the total authenticity that is missing everywhere else, and that day by day debases us." This moral prescription reminds us of Surrealism's origins and brings us to poetry where the event of the moment is the arrival in Paris of Sens plastique II by Malcolm de Chazal (late 1947). An engineer in Mauritius, Chazal, a reader of Swedenborg, used short percussive formulae in his poetry - only Magloire-Saint-Aude the Haitian, was more laconic than he. He applied the principal of analogy to meditation on the

identity of birth and death, that one can only know through the intimate experience of intimacy of voluptuous pleasure:

"Le gris est le cendrier du soleil. La volupté est un accouchement mutuel entre deux tombeaux charnels dans le cimetière désertique de l'esprit..."

"Grey is the sun's ashtray. Voluptuous pleasure is the mutual giving birth between two carnal tombs in the barren cemetery of the spirit..."

The Surrealists, who were slacking off a bit in Breton's L'Ode à Charles Fourrier (Ode to Charles Fourrier) received a veritable kick in the pants with Sens Plastique. In fact the young poets of the time were dominated by Henri Pichette, that friend of Artaud, who had just published his Apoèmes and had Roger Blin, Maria Casarès and Gérard Philippe take roles in his famous play Les Epiphanies (published by K, 1948): "Since the world's first heartbeat I circled around

Denise Bellon

Joyce Mansour

galerie Claude Oterelo, Paris.

myself like an inner circumference racket has always been intolerable for me I shared a room with monotony Sounds came to me without my being able to classify them I have a blue fright of space..." The magnificence of this outcry does not come from a fading form of Surrealism, but from the verbal magic of love that goes beyond tragedy.

The names of Maurice Blanchard, Aimé Césaire and Michel Leiris marked those years, when Julien Gracq was at the height of his creativity. He had come to Surrealism in 1947. Jose Corti published *Un beau ténébreux* (A Handsome Man of Dark, Brooding Good Looks), then *Liberté grande* (Great Freedom, 1947). *Le Rivage des Syrtes* (The Quicksand Shore) earned him the Prix Goncourt that he haughtily declined. *Un balcon en forêt* (A Balcony in the Forest) recounted his war souvenirs. We should add that he adapted Kleist's *Penthesilea* and participated, with Breton, in the writing *Farouche à quatre feuilles* (1954).

"It is a young woman from under whose steps an abun-

Julien Gracq at the time of the Prix Goncourt 1951, which he refused.

dance of images emerge. Sometimes, on April's path, she lifts a hand gentle and soft like a feather and regretfully calms the landscape's worries,—or perhaps..." ["Inabordable" in Liberté grande]

Jindrich Heisler came out of the underground in Prague, arriving in Paris in 1947. Toyen's illustrator, his work as an illustrator for Néon, his research in film and his dutiful presence in the Solution surréaliste office (Rue du Dragon, Paris) made him an active member of Breton's group. In 1956 he was to publish Les Spectres du désert (Ghosts of the Desert). Georges Hénein, born in Cairo in 1914, founded the review La Part du sable (The Share of the Sand), in Cairo in 1947 along with Ramsès Youmane. He ceased all contact with the Parisian group as of in 1950. The poetry of this representative of Surrealism in the Muslim world, made him a precursor to the Iraqi El Janaby. El Janaby created the review *Le Désir liberataire* (Libertarian Desire) in 1973 and was to violently contest the Koran: "Here is a world in which the pedantic sell the past to those who fear the future..."

A younger generation including Suzanne Allen, Édouard Jaguer, published their poems in Le Surréalisme révolutionnaire: "Enough joking, what little ninny sucks her sugary fibroid tumors right up to the end in conjunctive pomposity? Let us pose the question in another manner. Have nuns rendered shame more compact? (S. Allen, "Suite physiologique"). And Jaguer: "You should shred her corsage great sun/You should screwthread the squirrel by its throat/His great bell tower of brambles and oats..." ("Roue à miel ou l'eau bœuf"). Gérard Legrand, who was very close to Breton since 1948, published Des pierres de mouvance (Stones within a Sphere of Influence) in 1953. And Jean Malrieu, Préface à l'amour, the same year. Cris, the first collection by the Egyptian, Joyce Mansour, was published by Seghers. She published Déchirures

(Editions de Minuit) in 1955. Her poems struck the Surrealists by a kind of freedom where sex goes hand in hand with violence; "The amazone ate her last breast/The night before the final battle..." (Cris). Let us mention in addition, Jehan Mayoux, E.L.T. Mesens, who organized the 1945 exhibition, Surrealist Diversity, in London, André Pieyre de Mandiargues, Octovio Paz, Mariane Van Hirtum, Unica Zurn, the Peruvian, Cesare Moro, who published Trafalgar Square in Lima, 1954, before dying of Leukaemia in 1955, the Belgian Paul Nougé, with three works between 1946 and 1956, Gisèle Prassinos, child-poet, the Egyptian Georges Schéhadé, who published nine books between 1947 and 1956. We can see that the abundance of works didn't let up; even death didn't play a role.

dré Pieyre de Mandiargues.

Eroznanatos

Éluard died in 1952. Since the age of thirty, this war veteran, victim of nerve gas, with the slightly haughty asymmetric face, had trembling hands... Dr. Mabille died the same year. The poet Joë Bousquet, bedridden for years, died in 1950. Death would strike heavily -1953, Picabia and Heisler; 1954, Frida Kahlo, Diego Rivera; 1955, Tanguy; 1956, Cesare Moro, 1958, Nezval; 1959, Péret; 1961, Nora Mitrani; 1962, Gaston Bachelard; 1963, Tzara; 1964, Fraenkel; 1966, Breton, Arp, Brauner; 1967, Magritte, Nougé, Brunius; 1968, Baskine; 1969, Malkine, Chavée; 1973, Picasso, Max Morise; 1974, Hugnet, Asger Jorn, Hénein; 1975, Bellmer; 1976, Queneau, Man Ray, Max Ernst, Molinier, Alexandre Calder; 1977, Prévert, Bryen, Chaplin; 1978, De Chirico; 1979, Dotremont; 1987, Hérold; 1988, Char; 1989, Dali; 1991, Tinguely; 1993, Naville; 1994, Jacques Doucet; 1996, Bédouin; 1999, Lorenc; 2000, Henri Pichette... There were also the suicides: 1957, Dominguez, on New Year's eve; 1959, Paalen and the young Jean-Pierre Duprey; 1969, Kay Sage; 1962, Seligmann; 1970, Unica Zurn; 1988, Iréna Dedicova...

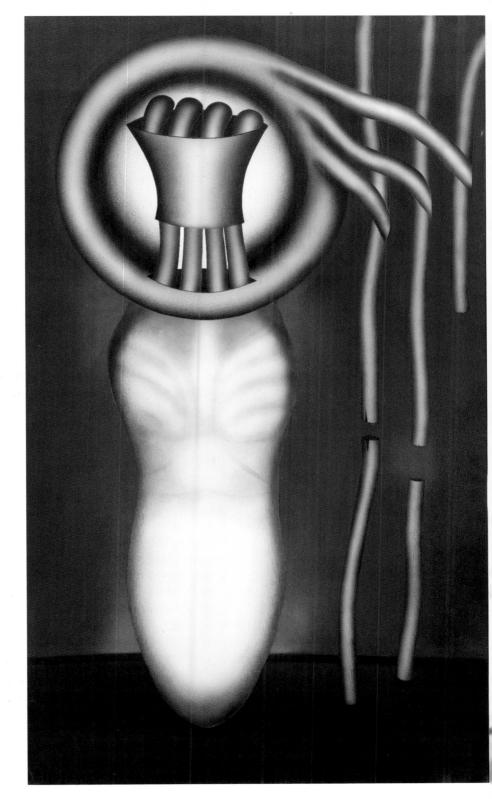

Previous page:

Irena Dédicova

The Persans,
1971, acrylique on canvas,
Private Collection.

Paul Éluard and Man Ray,

double spread from Facile 1935, musée d'Art et d'Histoire, Saint-Denis.

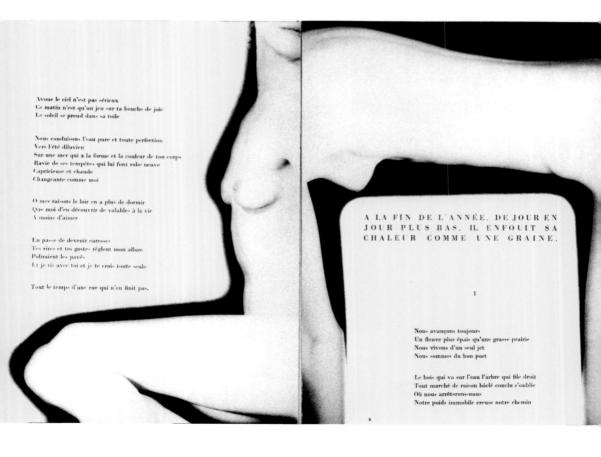

Given the birth dates of the leaders of "Historic Surrealism" except for the premature death of Nora Mitrani and J.-P. Duprey's suicide - these deaths have no Surrealist particularity. And even suicides are a general tendency in the twentieth century: the right to die, an obvious return to the dignity of the stoics. But in spite of the arrival of a number of young people, it seems possible that the accumulation of these deaths - and most of all André Breton's death - might have caused a certain depression within the movement. Breton had written that he "wasn't worried about. his own death." He was not however, indifferent to the deaths of his friends. Breton had been scarred by the ambiance of disaster in which he had spent his adolescence – which reached its most difficult point with Vaché's, and then Mayakovski's, suicides. His revolt against the fatality of death did not allow him to remain silent in the face of "that which doesn't depend on us." The difference between Stoicism and Surrealism is there: Surrealism thinks it honorable to protest against even the ineluctable, and that this revolt is as real and absolute in the poetic outcry of art, as in the fatality against which it rails. We can remember also that Surrealism makes the poet descend "into death" and one of the constants in Surrealist thinking is its' pessimism. This pessimism would separate the movement from Aragon, in political terms, and from COBRA in painting. The fight for social revolution implies that spiritual revolt risks being diluted in obedience to orders - Surrealism thus opposed its refusal. Inversely, anarchism as a political philosophy comes up against the application of its doctrine to realities of the present, hence its failure – and a new blunt answer was no. In a conference at the Mutualité hall in 1949. Breton opposes his anarchist friends in regard to the legalization of the status of conscientious objector, which would only favor seminarists, he said... The power of priests and the police? Where can one see that the power of the intellect had softened its impact on the crowds of the great crusades, or on the persistence of police regimes? Certainly, things evolve, but only step by step.

Breton's libertarian passion was never to mollify his critical capacity, anchored as it was in firm reason. This meant that his venerated precursors, such as Rimbaud or De Chirico, were spared nothing and treated harshly. It was difficult not to feel hurt by the incomprehension of those he admired. Freud — "I was tempted to consider the Surrealists complete mad men." Picasso? Breton would write in 1961 that he "would skip a step

when he remembers those moments long ago, when, with his heart beating, he would climb Picasso's staircase." For Picasso, before painting his troubling portrait of Stalin, was said to have "peopled'their atomic skies with so many bloodless and fallacious doves." (Le Surréalisme et la Peinture, p. 118). And all those dear friends that he had to exclude - Tzara (refound in 1929, lost again as of 1934), Éluard [1938], Dali of course [1938], Max Ernst (excluded on several occasions), Magritte, Matta, Brauner; all those refused with the Second Manifesto, Baron, Limbour, Masson, Prévert, Queneau, Vitrac, etc. Giacometti had chosen to follow his career as an artist. There were those who kept a certain distance - Soupault, Man Ray, Tanguy. Those he'd lost touch with - Desnos, Dominguez, Artaud himself, whom he hadn't heard from in America. Those who had loved you and than one hadn't known, or hadn't received, the young lions from La Main à plume, etc., and now, all these deaths... The very principles of Surrealist creation got somewhat lost in the abundance of discoveries and surplus of talent among the visual artists. The history of "L'écriture automatique (automatic writing) was a story of continuous misfortune" Breton wrote in 1934. So what was the stage of the game in the fifties and sixties? Love? Woman? -There was the perfect context for revolt, brought on by the powerful magic of the unconscious, that would give the mad quest for knowledge, the beginning of a sense of accomplishment. Breton wrote: "In spite of some memorable polls, the modern sexual world in which Sade and Freud work, has not, as far as I know, stopped countering our desire to penetrate the secrets of the universe, with its unperturbable core of night." (Introduction to Contes d'Arnim, 1933). The international exhibition of Surrealism (EROS) in 1959-60 at the galerie Cordier in Paris, would emphasize (and not without a secret solemnity) the Surrealists' predilection not only for the fusion of imagination and reality, but also that of the most free eroticism tinged with odoriferous love. As Gérard Legrand well put it in Dictionnaire général du surréalisme et de ses environs: "Knowledge without desire remains abstract, desire without know ledge becomes exhausted within its own satisfaction or becomes exasperated within its own frustration." The pre-opening of this exhibition was dedicated to L'Exécution du testament de Sade (Carrying Out Sade's Will and Testament), a performance by the Canadian poet Jean Benoit. Fascinated with Sade, the Surrealists had always allied fantastical eroticism with the general spirit of courtly love, supposedly unique, rebelling against social convention, and harbinger of supernatural, fantastic element. Hadn't Breton written that "poetry is made in bed, like love?" And Éluard, the great libertarian lover, published his 1935 poem to the glory of Nusch — "Facile" illustrating it with provocative photographs:

Ou bien rire ensemble dans les rues
Chaque pas plus léger plus rapide
Nous sommes deux à ne plus compter sur la sagesse
Avoue le ciel n'est pas sérieux
Ce matin n'est qu'un jeu sur ta bouche de joie
Le soleil se prend dans sa toile

Nous conduisons l'eau pure et toute perfection Vers l'été diluvien Sur une mer qui a la forme et la couleur de ton corps Ravie de ses tempêtes qui lui font robe neuve Capricieuse et chaude Changeante comme moi

O mes raisons le loir en a plus de dormir Que moi d'en découvrir de valables à la vie À moins d'aimer... Why not laugh together in the streets

Each step lighter faster

Neither you nor I no longer count on wisdom

Admit the sky is not serious

This morning is nothing but a game on your lips of joy

The sun is caught in its own web

We lead pure water and all perfection
Towards torrential summer
On a sea with the shape and color of your body
A sea thrilled with storms donning new garbs
Capricious and warm
Changeable like me

Oh my reasons the dormouse has more for sleeping Than I for discovering valid reasons for living Albeit to love...

It was said that Éluard had "offered" Nusch to Picasso as a gesture of friendship. But Picasso out of friendship for Nusch, refused... Love magnifies sexuality, yet goes far beyond it.

Dali's auto-erotic texts, his ardent praise of sodomy ("Reverie"), his famous painting *Jeune vierge auto-sodomisée par sa propre chasteté* (Young Virgin Self-

Salvador Dali

Young Virgin Auto Sodomised by her Own Chastety, 1954, oil on canvas, Private Collection.

Buggered by Her Own Chastity, 1944), encounter the most beautiful pages of *L'Amour fou*. The synthesis of romantic light and night of desire was a constant in the Surrealist ethic: "Love, love alone, carnal love, I adore it. I have never stopped loving your venomous shadow, your deadly shadow. A day will come when man will acknowledge you as his sole master, and honor you, even in those mysterious perversions that you surround yourself with." (*L'Amour fou*, p. 108). To Breton's profession of faith, corresponds a similar

affirmation made by the most erotically neurotic of Surrealist creators, Dali: "In love, I attach a great deal of importance to all that is called perversion and vice. I consider perversion and vice as the most revolutionary forms of thinking and behaving, just as I consider love as the only standpoint in a man's life." (*La femme visible*, 1930).

Far from hedonist sensations, and farther still from religious bans (denounced by Bertrand Poirot-Delpech in *Le Monde*, 22 May 1991, "People under fifty have no idea of the contentions, contortions and contrition to which the Church condemned its youthful flock in general between 1850 and 1950."), the Surrealists, in fact precursors of the post-May 68 "sexual revo-

lution" had integrated their ideas of revolt, atheism, the occult, and "Surrealist games" with their concept of love. How in the world could "question and answer games" have come up with this remarkable definition of eroticism: "It is a sumptuous ceremony, held underground?..."

The EROS exhibition was underground and sumptuous. The ceiling of the entryway was decorated with pink satin by Duchamp. Having gone through this "vaginal partition" one passed through a labyrinth full of sighs, and entered a "fetish chamber" then a sort of saint of saints, where a "cannibal feast" was taking place. Strictly excluding form of vulgarity, this exhibition followed a certain tradition of dreamlike sadomasochism found in Un chien andalou and L'Ange exterminateur by Buñuel. Objects by Bellmer, Duchamp, Jean Benoit punctuated this erotic space, a kind of global object where one entered as though entering the Original Cave. The catalogue Boîte alerte, included an erotic lexicon...

The "right-thinking" were scandalized of course, but they wouldn't go as far as destroying everything. The mystery of Eros, so obviously sought in this exhibition, undoubtedly imposed respect...

"THE FINAL SPLIT"